THE MEANINGS OF MODERN ART

by JOHN RUSSELL

Art Critic, *The New York Times*

VOLUME 12

HOW GOOD IS MODERN ART?

THE MUSEUM OF MODERN ART, NEW YORK

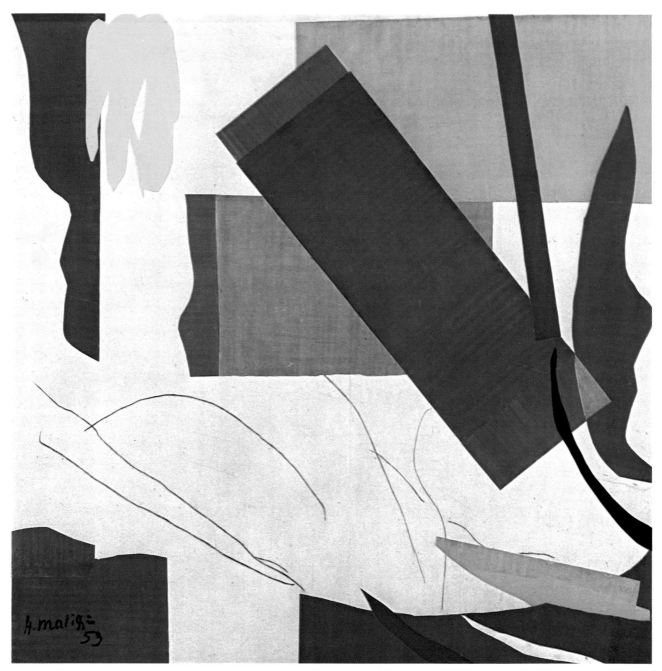

I. Henri Matisse
Memory of Oceania, 1953
The Museum of Modern Art, New York

In *Memory of Oceania* Matisse released memories which he had hoarded since
he went to the South Seas in 1930. He did not present them literally, or in a
descriptive way, but as almost disembodied essences which were left to float
on the surface of the canvas.

Copyright © 1975 by The Museum of Modern Art All rights reserved Library of Congress Catalog Card Number 72-76416
Series ISBN 0-87070-477-X Volume 12 ISBN 0-87070-489-3 Designed by Earl Tidwell
Cover: plate XII. Dan Flavin, *Untitled (to Alexandra),* 1973. Courtesy the artist and the St. Louis Art Museum

Face to face with new art, we begin a series of investigations. We test, and we taste. We refer back to what we know already. We think of what we always wanted to know but could never find anyone to tell us. We wait to see how the new art makes us feel: older or younger, richer or poorer, cleverer or more stupid, more at home in the world or less. These are true tests: and just very occasionally, when they all come out right, we burst out with the modern equivalent of a famous 19th-century cry, "Hats off, gentlemen, a masterpiece!"

It sounds pure gain. What is done in our time is done in our name, as I said earlier. We demand of new art that it should leave our generation with its claim upon posterity substantiated. Yet great news can be a great inconvenience, and new art may force us to reconsider our ideas not only about earlier art but about ourselves. After Cézanne, after a Picasso of 1910, after a Kandinsky Improvisation, earlier art looked different. T. S. Eliot put this point very well when he said that "when a new work of art is created, something happens simultaneously to all the works of art that preceded it. The existing monuments form an ideal order among themselves, which is modified by the introduction of the new (the really new) work of art among them."

We ourselves are modified, also, by the arrival of "the new (the really new) work of art." We ourselves may look different too: whence the tension, the disquiet, the outright mutiny with which it is so often received. "Is it good enough for me?" is the unspoken question which lies behind all our judgments of new art. But when the new art is also great art we have to ask another, and a less comfortable question: "Am I good enough for it?" The German poet Rainer Maria Rilke understood this when he wrote in 1908 of a certain sculpture that "after this, we must live differently."

So it is a happy day when good new art is also good news, everywhere and without qualification. This was the case with Matisse's cut-paper paintings of 1951–53, which were received with universal delight and astonishment and have stood ever since as perhaps our truest and most perfect image of human nature at one with itself. The world had needed just those paintings at just that time. It was a hinge-point in human affairs, and nowhere better defined than in the long poem called "Winds," which was written in the United States by the exiled French poet, St. John Perse, who was later to be awarded the Nobel Prize. The poem was Whitmanesque in its scale and sweep, and it described how "very great winds" had passed over mankind, leaving us with "men of straw in the year of straw." "For man is in question," St. John Perse said elsewhere in the poem: "Will no one, anywhere, raise his voice? It is for the poet to speak and to guide our judgment."

Those who felt, with Perse, that mankind "had a rendezvous with the end of an age" did better with painters, as it turned out, than with poets. Still, the images had to be found. And where to look for them? It had seemed an insoluble question. So much of European painting was like Europe itself: worn out. The best American painting was for the most part tragic in intention, as we have seen: what it had to offer was a portrait, complete and unflinching, of a flawed humanity. It also restated in terms of art what Henry James had had to say about Nathaniel Hawthorne—that "an American could be an artist, one of the finest, without 'going outside' about it and just by being American *enough*." These were great achievements, and they came to be recognized as such, but the strain showed; indeed, it was fundamental to the achievement. The early 1950s were a time of worldwide exhaustion and self-doubt; and to be what I have called "good news everywhere" the new art had to combat these states of mind. It had, in other words, to be as near as possible weightless, incorporeal, and exempt from all outward effort. It had to picture a world released from gravity and freed from guilt: a world in which Nature was wholly benign, and the sick were made well, and the unloved were loved.

It fell to Henri Matisse to picture this world, in circumstances which were really very curious. As early as 1943 he had said to a friend that "all signs indicate that I am about to start working on large-scale compositions, as if I had the whole of life, or another life, before me." As Matisse was then 73 years old and was often as not too ill even to stand before an easel, let alone to ply a brush, this might have been a protective illusion of the kind which often settles over the victims of terminal illness. But in his case it was the literal truth: at no time in his life did he produce more work on the scale of epic than between 1951 and his death in November, 1954.

Matisse at that time was preoccupied, as he had been all his life, with color. He could no longer brush huge areas of canvas, but such was the effect of infirmity upon his imagination that he decided to see how color could be magicked into being in ways that had not been exploited before. When he was invited to design a chapel for the Dominican Order in the little town of Vence, where he lived from 1943 to 1949, he could have used the firm strong color which he had commanded with total virtuosity in his paintings of the 1930s. But he opted in the end for the simplest of general schemes, dominated by black line drawings on a bone-white background. If color dances every day

1. Henri Matisse
Dahlias and Pomegranates, 1947
The Museum of Modern Art,
 New York

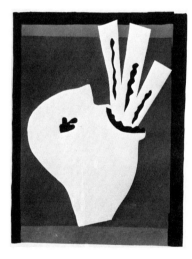

2. Henri Matisse
Nude with a Necklace, 1950
The Museum of Modern Art, New York

3. Henri Matisse
"The Sword Swallower," plate 13
 from *Jazz*, 1947
Published by Tériade for Editions Verve,
 Paris, 1947

A feature of *Jazz* was Matisse's hand-
written comments, which set out the
general principles by which he had
lived. Opposite his schematic sword
swallower, he wrote that the artist
needs all his energy, all his integrity,
and the greatest possible modesty if he
is not to fall back upon forms of
expression that have already been done
to death.

added up to what can be called a "late" style, in which the game was for high stakes and no bets were hedged. It was an old man's summation of an activity that he had pursued day after day, without stint or remission, for 60 years. As for color, it was elsewhere—except, of course, insofar as black and white are colors. Yet, in respect of color also, a 60 years' experience demanded to have a last word; and it began to get it in 1947 in a book by Matisse: *Jazz*.

Jazz was something quite new for Matisse. Already the title was a whole world away from the stately evocations of the French past with which he had busied himself in wartime. Jazz music at that time and for a man of Matisse's generation was still something dashing, exotic, specifically American. It stood for snappy cross-rhythms and euphoric riffs of a kind unprecedented in high art. It also stood for something not written down, immutably, but conjured from nowhere by people for whom improvisation was the touchstone of talent.

None of this would apply to Matisse's normal methods of drawing. He never made a mark on paper that did not speak for a long schooling and a sense of moral responsibility toward high art. But in *Jazz* he did not make marks on paper. He took sheets which had already been colored (so brightly in fact that his doctor advised him to wear dark glasses when looking at them) and he cut into them with scissors. There was no drawing, as such: he felt as if he were cutting into pure color as a sculptor cuts into marble. The scruples and inhibitions of high art fell away, and images of a kind he had never tackled before rose up freely from his unconscious. Sometimes they were images of violent action; sometimes memories of Tahiti come back after 20 years; sometimes fantasy took over after a long lifetime dedicated primarily to fact. The man who had largely eschewed pure invention turned out to be haunted by scenes from a Texan rodeo that he had never been to, by sword swallowers from an imaginary circus, and by the fate of Icarus as he fell soundlessly through space. The stay-at-home reinvented the marvels of the Polynesian seabed. The most matter-of-fact of great masters pictured for himself the funeral of Pierrot, with white horses drawing a monumental hearse and just one small splash of red to stand for the wreaths on the coffin. In *Jazz*, Matisse completed himself. What had been left unsaid was said, and with an effect of long-pent-up excitement. It was unthinkable that so vivid and so rewarding a medium would be used once and once only.

There were difficulties, of course. The scale of *Jazz* was such that he could work on it in bed without exhausting himself. For anything larger, other methods would have to be found. Eventually, however, and with the help of his assistant Lydia Delektor-

through the Vence chapel, it is not because of what is on the wall, but because the stained glass windows flood the white interior space with the ghost of pure color: where all else is black and white, sheets of palest blue, green and yellow cross and recross the floor, visible but impalpable.

Both in his designs for the Vence chapel and on individual sheets of paper, Matisse in the late 1940s was drawing with an exceptional power and freedom. The deep black of the ink, the summary unerring line, the breadth and force of the stroke: all

skaya, Matisse decided that he could work on very large sheets of colored paper by using long-handled shears. The cut-out forms could be first pinned down and later definitively stuck in place; as for the area to be covered, there was no need to set a limit to it. Twelve feet by twenty-five (as in *The Siren and the Parakeet* of 1952) was none too large. There was never a complete break with his own past: the emblems of Nature were such as he had often outlined in pen and ink, the heavy-limbed girls took poses of a kind he had often studied for his sculptures, the glimpses of the human body at full stretch in deep water harked back to the grouped dancers whom he had pictured with such authority in 1909 and again in the 1930s (Volume 9). But something had vanished from the work all the same; and that something was the evidence of hard labor.

The cut-outs did not look "easy," any more than *Dance* of 1909 (Volume 2) had looked "difficult." They just seemed to have been wished out of the air, instinctively and instantaneously. It wasn't true, of course, but it seemed to be true; and when the big cut-outs were first put on show they came upon the world like an act of amnesty. All sins were forgiven; something had come into being that was perfect, whole, and complete. That so large a body of work should be produced by someone who was in medical terms a dying man was really very extraordinary; it was as if the processes of nature had been reversed and death had been kept waiting at the door. So all-pervasive to this day is the effect of the cut-paper works that they have caused, quite unjustly, a relative decline in the reputation of those earlier, old-style paintings by Matisse in which the evidence of hard labor is there for all to see. It can be argued that the very perfection of the cut-papers puts them lower in the scale of moral effort than the oils on canvas in which Matisse took the classic problems of painting and tussled with them in the traditional way; but in the convalescent Europe of the 1950s people were grateful enough to have set before them the image of an unflawed and primal happiness. Faced with something the like of which had not been seen before, they could have said, with Ralph Waldo Emerson, "I have enjoyed a perfect exhilaration. I am glad to the brink of fear."

Only one man could do it, however. It is the paradox of Matisse's cut-paper paintings, which look so quintessentially youthful and unburdened, that in point of fact they signal the old age of the European masterpiece. There had been nothing like them before, and there would be nothing like them again. Not only was there no one around who could do it, but Matisse's broad exalted confidence in the role of the masterpiece was even then ebbing away from the European consciousness. It was part of a

4. Helen Frankenthaler
Hommage à H. M. (Henri Matisse), 1971
Mrs. Ralph Mills, Jr., Chicago

In the 1960s and early '70s Helen Frankenthaler developed a mastery of irregular placement. Patches of color—themselves enigmatic in their outline—were allowed to maneuver freely, according to a logic of their own. In this particular painting the element of drawing-in-paint could allude to the work of the man who excelled, as much as anyone in the history of art, in drawing and painting alike.

more general decline. The demoralization of an entire continent is not something that can go unreflected in the mirror of art. If that decline and that demoralization were not more immediately apparent in art, it is because the dominant figures in that art were still the men who had come to manhood at the end of the 19th century and had that century's belief in the absolute power

5

5. Pablo Picasso
Les Femmes d'Alger, February 14, 1955
Mr. and Mrs. Victor W. Ganz, New York

In 1955 Picasso paraphrased Eugène Delacroix's *The Women of Algiers* over
and over again. What he did was to remake the painting—one of the crown
jewels of the Louvre—in his own image, with an effect of ever greater
brilliance and forthrightness.

of art. Not only had these artists a glorious past, but in more than
one case they had a glorious future. Even where they had died
(Klee in 1940, Mondrian in 1944, Kandinsky in 1944, Bonnard in
1947) their late work came upon the world as a delayed revela-
tion. Where they lived on (Matisse until 1954, Braque until 1963,
Duchamp until 1968, Picasso until 1973) it was not as ancient
monuments or revered figures who happened not to have died,
but as people who still had plenty to say. Braque was never better
than in his late Studio series; Picasso reached perhaps his highest
point of virtuosity in the variations on *Las Meninas* by Velázquez
and *The Women of Algiers* by Delacroix (fig. 5); Duchamp over-
turned every assessment of his career by working in secret for
20 years on an environmental work (*Etant donnés: 1° la chute
d'eau, 2° le gaz d'éclairage/Given: 1. The Waterfall, 2. The Illu-
minating Gas,* 1946–66), which was made known only after his
death. Talk of decline makes no sense, in this context. But art is
a collective as well as a personal matter; and in that regard times
were changing too fast for comfort.

WHAT HAPPENED TO THE MASTERPIECE?

What went wrong with the idea of the masterpiece? One way
to open up this question is to look at one of the last occasions
on which the traditional certainties were asserted with maxi-
mum force. In 1902 Max Klinger completed a seated figure of
Beethoven. White, black and violet marbles, alabaster and ivory—
all were brought into play. The great man was portrayed naked,
though draped in Roman style; his throne was big enough for
any two ordinary men; he had that visionary look which was
mandatory in posthumous portraits of the kind. An eagle sat at
his feet. Angels urged him on at shoulder-height. Klinger is
known to us here for his print series *The Glove* (Volumes 3 and
7); but in the Beethoven statue he made the kind of grandiose
public statement which in 1902 was still perfectly acceptable. So
acceptable was it, in fact, that Klinger was welcomed by a salute
from the trombones of the Vienna Philharmonic orchestra when
the statue was shown in Beethoven's own city.

What has caused Klinger's *Beethoven* to sink without a trace
is not so much the overblown rhetoric of the sculpture itself as
the collapse of belief in the role of art as the custodian of current
values. The mid-century view has been that since most accepted
values are pernicious, art is not art if it supports them. The art
which has lately commanded respect is the kind which goes its
own way, attentive to art's own historical necessities but indif-
ferent to officialdom. Individual artists may or may not take a
political stand. On January 1, 1966, Alexander Calder took a page
in *The New York Times,* at his sole expense, to put himself and
Mrs. Calder on record as believing that: "Our only hope is in
thoughtful men. Reason is not Treason"—and there have been
works of art which likewise take a specific stand: James Rosen-
quist's *F-111* is the outstanding example (Volume 11), and the
cycle of David Smith's Medals for Dishonor should also be re-
membered. But basically the big rounded statement, such as was
welcomed in 1902, is no longer tolerable to most artists. This is
not because they have opted out, or because they refuse the
challenge, but because the conditions of life no longer allow of
that kind of panoramic certainty. Certainty has now a narrower
compass; and even within that compass there are elements that
are conditional or contingent.

This is in part because our view of the world is now permeated
with the need to question and revise and readjust which was
initiated in physics before 1914 by Albert Einstein and Max Planck
and Ernest Rutherford. This is not to say that these august names
can be invoked by anyone who looks at the state of the world
and says, "It just doesn't make any sense"; but it does mean, as

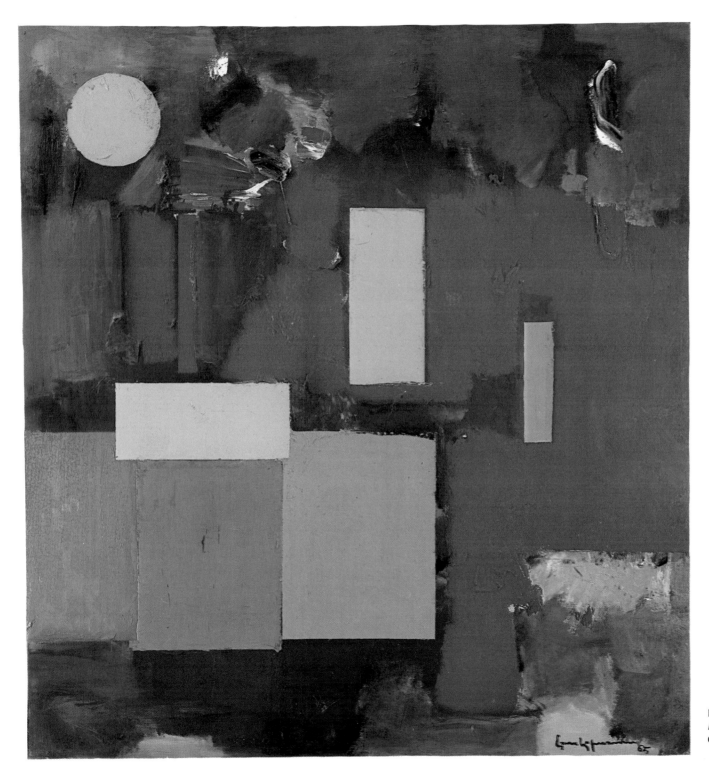

II. Hans Hofmann
Rising Moon, 1965
Courtesy André Emmerich
Gallery; New York

the English historian James Joll has pointed out, that "Einstein's theory of relativity not only led to a scientific revolution; it seemed in the popular mind to confirm a widespread belief that nothing was certain any more." If matter is not matter, and if the stone that stubs our toe is not really solid, what are we to choose as tokens of reality? The masterpiece as monolith—"a single block of stone, especially one of notable size," says the dictionary—is devalued by definition if the "single block of stone" is not what it seems.

There is also the fact that the classic notion of the masterpiece has within it an element of self-congratulation. What people said to one another was that "a society which can produce *this* cannot have too much wrong with it." But the truth is that it is difficult to point to a great power which has not, at some point in this century, been ruled by buffoons or criminals; that it would be difficult to point to a great city, a landscape, or a stretch of offshore water which has not been contaminated, during that same period, by human action; and that it would be difficult to point to a social system or a set of beliefs which has remained stable, intact and unchallenged since the days of our grandfathers. This being so, it is not the function of art to patch over the shortcomings of society. The function of art, as the composer John Cage once said, is something quite different: to awaken us to "the very life we're living."

In this context we should see the late works of Matisse as above all a triumph of continuance. Matisse is one of the rare men who have held time at bay: in his art, and in his own body. It was not that the clock was stopped, but rather that the clock had been thrown away and was never referred to. Matisse was armored against the world. Other and younger artists were not, however; nor did other great seniors—Picasso and Braque, for instance—maintain in their work quite that immunity from current events which characterized Matisse. (The slow rundown of life in occupied France during World War II was evoked by both Picasso and Braque with a power which was all the greater for its relative discretion.) But it was left for another generation to suggest that the whole structure of accepted art had been as much a fraud and a sham in France as the structure of military "defense."

What happened in France by 1944 was that the previously established order was in total disrepute, that accepted systems of judgment were entirely discredited, and that hierarchies long taken for granted were thrown into the shredder. There was a situation vacant, at that time, for someone who could make first-rate art and yet nowhere bear the taint of a pre-1939 aesthetic. The situation brought forward the man, as it often does; and the man was Jean Dubuffet, a wine wholesaler turned painter, who had his first exhibition in October, 1944, just a few weeks after the Germans had been turned out of Paris.

Dubuffet belonged to that close-knit Parisian milieu in which art and literature overlap; and he was known there as an inimitable human being, an original among originals, with a strong line in the kind of elasticized dialectic which can be pulled this way and that, at will, and yet always snap back into place. He was a dazzling and prolific writer, whose published polemical writings for the years 1946–67 came to over a thousand pages. And in 1944–45, when most people longed only to see the return of French high culture as it had existed till 1939, Dubuffet outraged his countrymen by saying that museum art was grossly overrated and that there was quite as much to be learned from the art of madmen and guttersnipes. France had been producing great art in such quantity and for so many years that a lifetime was none too long for anyone who wanted to know it thoroughly. Rather than look around for the new and the difficult, people were delighted to settle, where the art of their own day was concerned, for the point of view epitomized once and for all by William Butler Yeats in his poem "The Nineteenth Century and After":

> Though the great song return no more
> There's keen delight in what we have:
> The rattle of pebbles on the shore
> Under the receding wave.

Dubuffet despised this point of view. Not only did he oppose it in print, but his own paintings were the antithesis of the polite, well-made, undemanding work of those who followed the masters of the French School at a respectful distance. His pictures looked as if they had not been painted at all, but scored in mud with a pointed stick. Their subject matter was rudimentary, their awkwardness quite flagrant, their total effect nearer to metropolitan graffiti than to traditional painting. He spared nothing and nobody. Yet if the early Dubuffet now stands out, it is not as an iconoclast. He gave, on the contrary, a paradoxical, unforeseeable grandeur to what were derided at the time as impudent scrawls and scribbles. It is to him, against all the odds, that the European imagination attached itself; and it is through him that the dream of a freer, franker, and yet not less humane mode of utterance was carried forward in art.

Dubuffet in all this looked both backward and forward. His ideas were in line, that is to say, with avant-garde attitudes as they had expressed themselves in Europe for many years past. As a young man he had been deeply impressed by Hans Prinz-

6. Jean Dubuffet
The Coffee Grinder,
1945
Mr. and Mrs. Ralph
F. Colin, New York

7. Jean Dubuffet
Touring Club, 1946
Richard S. Zeisler, New York

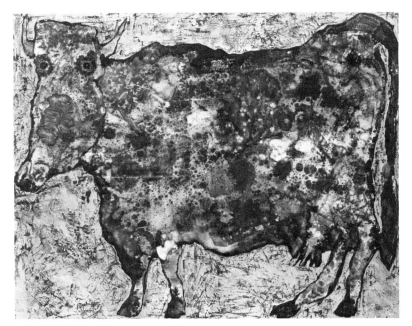

8. Jean Dubuffet
The Cow with the Subtile Nose, 1954
The Museum of Modern Art, New York

horn's book, first published in 1922, on the paintings of the men-tally ill; but Max Ernst had been preoccupied with such things since before 1914. Dubuffet welcomed chance into his art as a full partner—"It takes two," he wrote, "to dance this dance"—but then chance had been built into the notion of art since the early days of Surrealism. At a time when John Cage was quite unknown in Paris, Dubuffet had the same ideas as he about the expressive power of sounds from everyday life. "I know that musicians don't want to hear about them and consider them merely as 'noise,'" he wrote in 1946; "but I don't see why the sound of a chair being dragged along the floor, of an elevator starting its ascent, or of the turning-on of a faucet of water should not have its place in music, every bit as much as the twelve starveling and arbitrary notes of the scale."

Dubuffet arrived by his own calculations at idea after idea which had been, or was to be, propagated elsewhere as basic to a modernist attitude to life. In 1944, for example, he wrote to a friend that he did not believe in the notion of artistic gifts and that there was no reason why one person should not paint as well as another. In this he paralleled one of the most radical ideas of R. Buckminster Fuller—that "every child is a genius until it is de-geniused by education." Dubuffet was also, in those early

days, for an anonymous art as distinct from the 50 years of adulation which causes a once-gifted artist to rely on his signature alone; in this, he prefigured the revolt of the late 1960s against the kind of art which stands barely higher than autograph hunting in the hierarchy of human experience. His was an art that began from zero; but in this, once again, he had been preceded by Paul Klee, who once said that he wanted to work as if European art had never existed and everything could begin again from the beginning. So he was both new and not new; but if some of his ideas had been in the air for a generation Dubuffet nonetheless brought to them an incisive, quizzical, unsparing turn of mind that was specifically his own. At what might otherwise have been a low point in the history of French creativity he was able to reassert that there is no imaginative need for which an image cannot be forthcoming.

Dubuffet was already over 40 when he turned to painting full time in 1942; but his was a new name in art and he brought to art itself a new attitude—one that was half-derisory, half-magical. He made magic from derision, in fact; but the magic was too strong for a genteel taste, and it was to be a number of years before the best of his early paintings were found to validate the very thing that he had made mock of: the continuity of high art in no matter how surprising a form. Beneath all his bravado Dubuffet turned out to have reinvigorated the ancient categories of art—the portrait that is searching but never merely malicious, the still life of familiar objects, the townscape that manifests a novelist's eye for detail.

That art should start again from zero was the concern of another artist in Paris in the late 1940s. Alberto Giacometti's was not a new name; as we have seen, his gift for the invention of cryptic and poetical objects had given him a place all his own in the history of Surrealism. But when Giacometti returned to Paris from his native Switzerland in 1945 he brought with him a new preoccupation, a new kind of physicality in sculpture, and an existential view of "the masterpiece." "Existential" was everyone's favorite adjective in Paris at that time; and it referred not only to the philosophy which was associated primarily with the name of Jean-Paul Sartre but, more colloquially, with the belief that in all human enterprises the odds are stacked against us and that all we can do is to play a losing game as lucidly as possible. This belief related exactly to the conditions of life in German-occupied France; and it found a most vivid outlet in such key works of the time as Sartre's play *No Exit* and Albert Camus's novel *The Stranger*. ("On Joue Perdant"—"You Can't Win"—is a classic title of the period.) But it had also a more general implication: that our century has eaten away at beliefs once taken for granted—the unity of human personality, the unity of matter, the unity of space and time—and that it is the role of art to come to terms with that erosion.

This is where Giacometti came in. Ever since he had read Nietzsche and Schopenhauer at the age of 12, he had been familiar with the tragic sense of human destiny which was fundamental to everyday life in France between 1940 and 1945. Nobody was more inventive than he when it came to finding a metaphor for imminent doom; we remember, here, the *Woman with Her Throat Cut* of 1932 (Volume 7), but when that doom became a fact of political history with the coming to power of Hitler in Germany in 1933, Giacometti began to turn to quite another aspect of art.

"I knew that one day," he said later, "I'd have to sit down on a stool in front of a model and copy what I saw." His colleagues among the Surrealists were appalled—"As if everyone didn't know what a head is!" was André Breton's reaction—but to Giacometti it seemed that the most adventurous thing which remained for art to do was to reinvent the idea of likeness. On this one card, as Simone de Beauvoir said in her memoirs, he staked everything. He sat down and tried to say exactly what it was like to be in the presence of another human being. And he tried to do it as if no one had ever done it before: to start from zero. He did it, as he said himself, "with no hope of succeeding." What do we really see? What do we mean by likeness? What are we to do with the formless, blubber-like space which separates us from the person we are looking at? How can we possibly recapture the total experience? What if the sculpture, even if passable in itself, is falsified by its relation to the world around it? These were the problems which Giacometti tried to deal with. While dealing with them from 1935 to 1947 he never had an exhibition. Nothing satisfied him: his aim was, as Sartre wrote in 1948, to "cut the fat off space" until only the lean meat of experience remained; un-learning was as important as learning, in this context, and the work was bound to go through some peculiar phases. (Among other things, it got very small: the complete surviving work of the years 1942–45 could be transported in six matchboxes.)

It was as a result of these preoccupations that Giacometti eventually found three-dimensional equivalents for things that sculpture had not previously to do with: the fugacity of sense-impressions, for instance, the unstable or at any rate unseizable nature of human personality, and the arbitrary deformations which are imposed on the human figure by memory, by its surroundings at any given time, or by the chance involvements of looking. We can see today that the break with the sculpture of

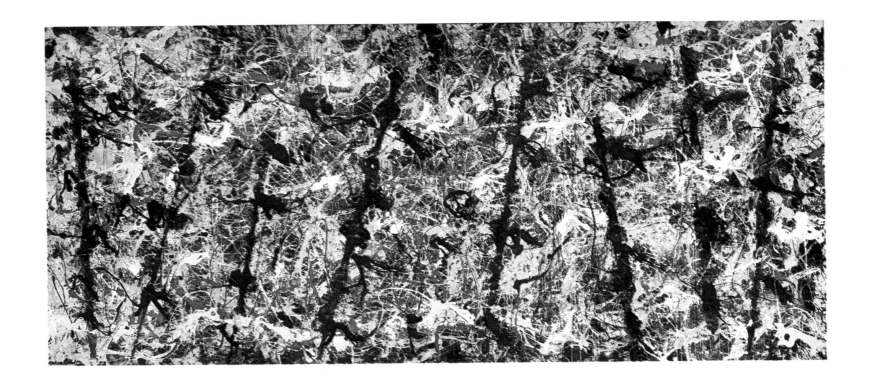

III. Jackson Pollock
Blue Poles (Number 11, 1952), 1953
Australian National Gallery, Canberra

An adventitious notoriety attached to *Blue Poles* from the moment that the
Australian National Gallery was known to have paid two million dollars for it.
Quite apart from its status as "the most expensive American painting" (to date),
it is an outstandingly sumptuous example of the moment at which Pollock's
art was on the edge of over-ripeness. In the poles themselves, with their
suggestion of windblown and tattered flags, there is a rhetorical element which
was outlawed in such earlier paintings as *Number 1,* 1948 (Volume 10).

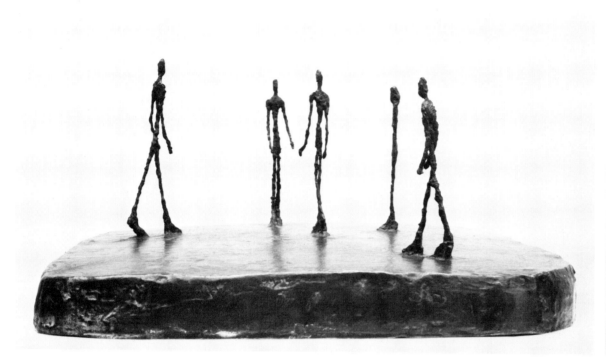

9. Alberto Giacometti
City Square, 1948
The Museum of Modern Art, New York

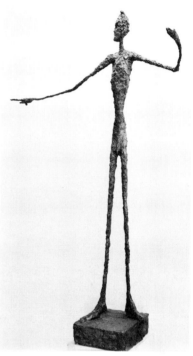

10. Alberto Giacometti
Man Pointing, 1947
The Museum of Modern Art, New York

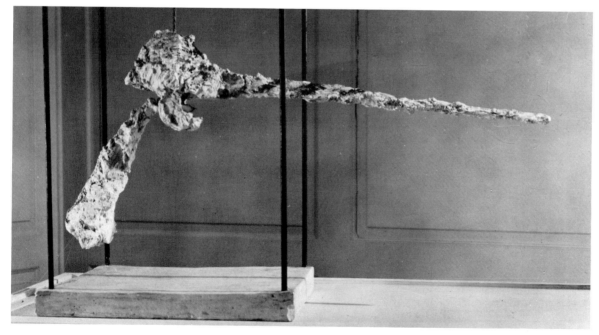

11. Alberto Giacometti
The Nose, 1947
Kunstmuseum, Basel, Switzerland

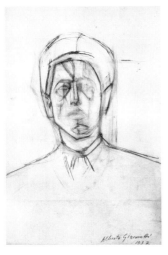

12. Alberto Giacometti
Self-Portrait, 1937
Private collection, New York

Giacometti in 1934 made a series of what he called "cubist heads." In these, the elements of the human head—eyes, nose, ears, jaw—did battle with the pristine form of the cube, pushing and pulling until resolution was achieved. Three years later he profited by this experience when drawing his own head in terms that were clear, crisp and decisive.

the past was not as complete as it once seemed; the *Man Pointing* of 1947 (fig. 10) had a look of Rodin, for instance. Nor did Giacometti lose altogether the Gogol-like feeling for the grotesque which had marked some of his Surrealist pieces; the plaster version of *The Nose,* 1947 (fig. 11), is a telling example of this. But in general what Giacometti had to say about the poignancy and the incompleteness of human relations was completely new—as were, equally, his ways of saying it. Big-city life looks different when we have seen Giacometti's the *City Square,* 1948 (fig. 9); and as for the act of offering oneself, whether from love or for money, it was re-imagined in the *Four Figures on a Pedestal* of 1950, just as it had been re-imagined in Manet's *Olympia* (Volume 1). "Here we are. What are you going to do about it?" is what the four girls have to say: as with Dubuffet, the central themes of European art are recalled and furthered, even if the immediate obsessions are of an unprecedented sort.

Giacometti was the last person to make claims for his own work—he would invariably say, in fact, that it was a disaster from start to finish—but in his actions he was true to the European notion that a career in art should be cumulative and that ideally the work should grow in weight, and in density, and in its power of commitment, year by year. There was to be no coasting along on the remains of a great name; recruitment was for life, or not at all. This was what Matisse had believed, and Braque, and Klee. It was what Picasso lived up to, with a determination to put all of himself on record, no matter what the consequences. It was what Piet Mondrian thought, too; and of the Europeans who came to live in the United States in the 1940s it was perhaps Mondrian who best exemplified the principle—one could almost say the duty—of continual growth.

THE END OF EVERYTHING OLD?

Mondrian was quite specific on this point. Already in 1924 he had written, "We are at a turning point in the history of culture. We are at the end of everything *old,* in a total and all-comprehensive sense. The divorce between the old and the new is now absolute and definitive." In 1942, when he was living in New York, he wrote, "Art must not only move parallel to human purposes. It must advance ahead of them." He believed, with the Indian mystic Krishnamurti, that it was the duty of every man to be "a force for evolution," and to do what he could to bring about a better world. "It is in human nature," Mondrian said toward the end of his life, "to love a static balance; the great struggle, and the one which every artist must undertake, is to annihilate a static equilibrium."

Mondrian had always abhorred "a static balance" in his own work. To avoid it, he went to enormous though largely invisible pains, working over and over until the finished painting was at every point the expression of a free man's hand—and, beyond that, of a free man's existence in the world. When he arrived in the United States he took the risk that every exile takes: that of total disorientation. There were Europeans in New York at that time who ate exiles' food, read exiles' newspapers, chased all around the town for exiles' tobacco, and sought the company only of other exiles. Mondrian was the opposite. "I feel here is the place to be," he said in 1943, "and I am becoming an American citizen. Where you live you belong to it, and when you feel a place is the nearest to you, you should become part of it."

Mondrian saw the new as a process of continual evolution. When he lived in New York, he felt that the best way for his art to "advance ahead of human purposes" was that he should annihilate the "static equilibrium" which for many years had characterized the means which he allowed himself: the rectangular areas of red, blue and yellow, separated from one another by unbroken black lines of varying thicknesses. What if the black lines were to go, and unbroken lines of pure color—still red, blue, and yellow—were to be allowed to overlap? What if he were to move on from there and work from a completely new constituent unit, the small square or rectangle, while retaining the linear crisscross as the basic compositional schema? Would not these changes correspond to evolutionary developments in other domains of life?

Behind these thoughts lay the conviction that life could still be mastered. This has now become something of a historical curiosity: something that it is very difficult to put forward with confidence. In the 17th century, and even in the 18th, it was believed

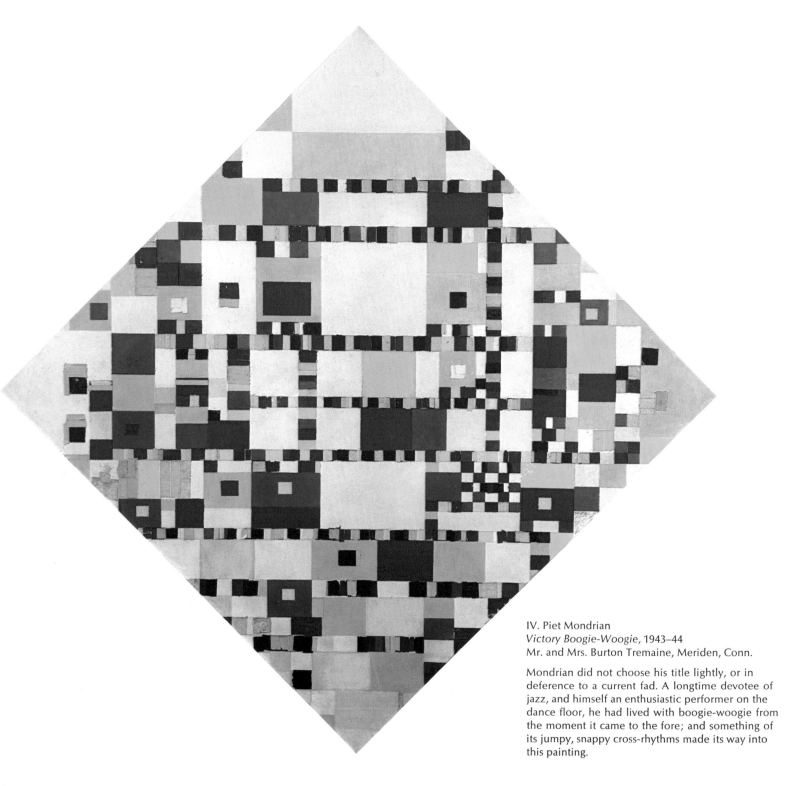

IV. Piet Mondrian
Victory Boogie-Woogie, 1943–44
Mr. and Mrs. Burton Tremaine, Meriden, Conn.

Mondrian did not choose his title lightly, or in deference to a current fad. A longtime devotee of jazz, and himself an enthusiastic performer on the dance floor, he had lived with boogie-woogie from the moment it came to the fore; and something of its jumpy, snappy cross-rhythms made its way into this painting.

that everything worth knowing could be put within the covers of a single publication. Nor was there anything in that publication that need overtax a trained intelligence. It was in this belief that the Encyclopaedia of Diderot and d'Alembert began publication in 1751. Everything was in that book, from the best way to make a pair of gloves to the latest thing in scientific research. Such a project today would make no sense. Not only is there more to know than any one person can encompass, but mankind has gone so far wrong in so many directions that it may already be too late to arrest the consequences of our errors. Life may be not only unmastered but unmasterable. The evolution which Mondrian believed in may be oriented toward disaster. The role of the artist may become purely consolatory: that of a cool-fingered nurse at the bedside of someone who will never recover.

This was not how it looked at the time of Mondrian's death in February, 1944. But, given the premonitory nature of art, we should not see it as a mark of old age and declining health that Mondrian in more than one case was unable to complete his New York paintings. They were more complex than any he had attempted before—in fact they make many of his paintings of the 1920s and early '30s look almost epigrammatic—and they raised problems of resolution which it remained for a later generation to tackle completely. But their incompleteness was not of the kind that halted Michelangelo when he was carving his late *Pietà*, or of the kind that brought Haydn to a stop after the first two movements of his last string quartet. It was an echo of that incapacity to bring great undertakings to a formal conclusion which is one of the marks of this century. In this context we remember Arnold Schoenberg, who broke off his opera *Moses and Aaron* at the end of Act II; Marcel Duchamp, who never quite finished the *Large Glass* (Volume 6); Ezra Pound, with his open-ended series of *Cantos*; Robert Musil, whose three-volume novel, *The Man without Qualities,* ends in mid-air. These were not men of puny energies; they just had an intimation that a time was coming when the world could no longer be mastered, and that for that reason the 19th-century ideal of the well-rounded masterpiece was no longer true to the facts of life. Marcel Proust may have been the last man in history to undertake a complete survey of life as it presented itself to a supremely intelligent observer and bring it to a majestic and shapely conclusion; and he was only able to do it from a point of view that was by turns stoical and deeply pessimistic.

Mondrian had quite other ideas, and at the end of his life he wanted to devise a more complex metaphor for the encounters, the misadventures and the mutual accommodations of which life is made up. Once or twice, he succeeded. Art exists, as we know, to negotiate with life on our behalf, and if possible to come to terms with it in ways that will help us live. But if those negotiations cannot be brought to a successful conclusion, it is the duty of the artist to bring back a true bill: an unfinished work in which we glimpse both the nobility of the initial program and the point beyond which no one, no matter how gifted, could go further. That is the significance of Mondrian's unfinished paintings.

Art as an instrument of mediation between ourselves and the world was never in safer hands than during the first half of this century. Modern art as it then existed was the quintessence of modernity, if by modernity we mean an alert, resourceful and unprejudiced enquiry into those aspects of life which are specifically of our own day. But there is a fundamental difference between the art of the first half of this century and the art of earlier periods of high achievement. If we look at the art of the Italian Renaissance, or at Baroque art, or at Romantic or Neo-Classical art, we can go quite a long way down the ladder and still find work that commands our interest and our respect. The little masters of 17th-century Holland are not in the class of Rembrandt or Cuyp or Frans Hals, but they are good enough to look at, and to think about, and to talk about, year after year. Minor artists in these periods were lifted above and beyond themselves by collective and impersonal forces: a shared level of technical proficiency, a shared and luxuriant subject matter, a shared sense that art was speaking for the age in a way that nothing else did, a documentary interest now taken over by other forms of expression. We have none of these things. Such is our belief in individual and inimitable genius that, by definition, only a very few people at any one time can be accepted as artists of consequence. When André Gide was the most famous writer in Europe in the mid-1940s, he wrote that "the world will be saved by one or two people." Gide was born in 1869 and was the contemporary, therefore, of Matisse and Proust. He took it for granted, as they did, that the burdens of art and literature would be shouldered for eternity, as they had been shouldered in his own long lifetime, by "one or two people." He also believed that that elite could not, in the nature of things, be enlarged.

It was then taken for granted that the finite and stationary structure was the highest form of art. When Matisse and Picasso and Braque and Mondrian painted their last pictures, the norms to which they conformed were exactly what they had been in the days of Raphael and Titian. If it surprised Marshall McLuhan that the form of the printed page should not have changed in the five centuries that had passed since the printing of the Gutenberg Bible, it should have been equally surprising to those who cared about such things that the formats and the materials in use

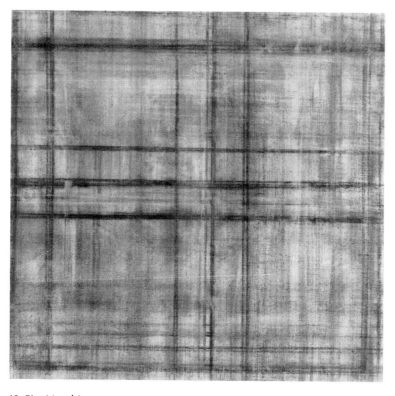

13. Piet Mondrian
Composition, 1938–44
Courtesy Sidney Janis Gallery, New York

Six years of intermittent work went into this charcoal sketch, which Mondrian was never able to resolve to his satisfaction. Its plaidlike markings nonetheless record the earnestness with which he tried to break through to a new mode of expression.

among the First New York School in 1947–52 were virtually identical with those of the panoramic landscapes of Rubens.

If this was taken as perfectly natural, it was in part because the work in question was so good as to delay any enquiry as to whether other formats and other materials would not be more apt for the time. It was also because the best new art was still having the kind of almost clandestine success which had been the lot of serious new art since the time of the first Impressionist exhibition in 1874. There was continuity in that fact. Not only was art being made by "one or two people," but it was being admired and bought by one or two people, just as D.-H. Kahnweiler had only one or two clients when he began to show Cubist paintings in Paris in 1908.

And there was, finally, the question of quality. Quality is what matters most in new art, and it is the only sure guarantee for its

continuance. Where quality is present in a very high degree, it usually results from a secret alliance with the past. That alliance may be concealed, as it was when Dubuffet literally dragged painting through the mud with his Corps de Dame series in 1950, or when the English painter Francis Bacon around the same time was producing what were then regarded as gratuitous scenes of horror, or when Roy Lichtenstein said that his ambition had been to paint pictures which were so despicable that nobody would put them on the wall. The secret was well kept in all three cases; but each had used a hot line to the past, even so.

Dubuffet had things to say about women's bodies that at first glance seemed merely coarse and derisive; but in point of fact he had truths to tell that had not been told in art before, and the final effect of these truths was to heal and not to wound. History caught up with Francis Bacon when every newspaper in the world carried photographs—presidential candidates in full spate, Adolf Eichmann on trial in his glass box in Jerusalem, unnamed prisoners in their cells—that looked like nothing so much as diluted Bacon. Before long it was clear, moreover, that Bacon's affinities were as much with Old Master painting as with the purely instinctive procedures which he freely acknowledged. After Roy Lichtenstein had been driving conservative connoisseurs to apoplexy for several years it turned out that he too had developed a subtle amalgam between an analytical awareness of past art and the modification of the image by industrial techniques.

In painting, at any rate, the finite and stationary structure—the picture that stayed flat on the wall, complete and in one of a few standard formats—had the advantage that no one had thought of anything better. Throughout the second quarter of this century, painting had all it could do to cope with what had been initiated by "one or two people" between 1900 and 1925. If we take what had been done by Matisse, Picasso and Braque before 1914, and if we add what had come in with the Surrealists between 1920 and 1925—the element of automatism, that is to say, and the freedom to draw upon the unconscious—the basic energy sources of painting in the first half of this century are complete.

Such was the momentum of those energies that it was possible to feel even in the 1950s that they were operating in Europe at an undiminished pressure. If painting had to a large extent turned in upon itself for subject matter, it had plenty to turn in upon. If there was self-evidently a big gap between the best artists and the next best, the answer was that the same had been true of the Impressionists, the Post-Impressionists, the Fauves, the Cubists and the Surrealists. Inequality is intrinsic to life. Meanwhile living

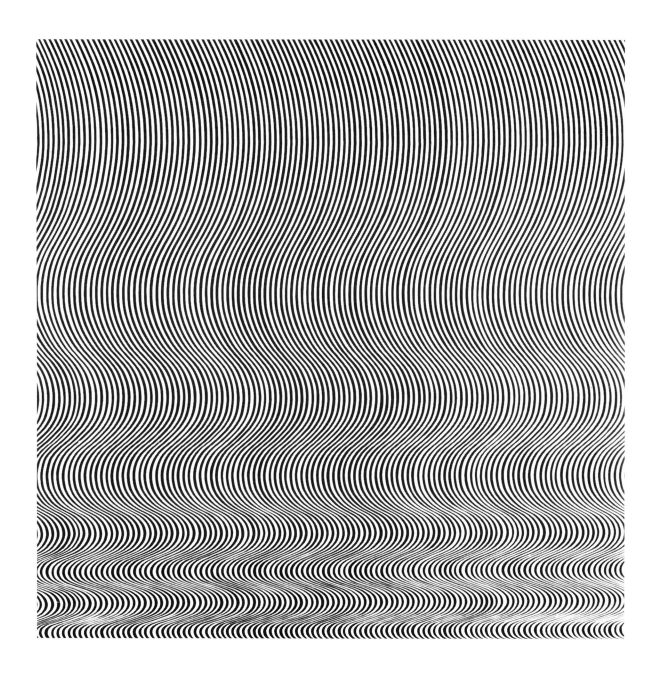

14. Bridget Riley
Fall, 1963
The Tate Gallery, London

At a time when abstract painting in the United States was much occupied with unequivocal statements conceived in terms of the straight line, a young British artist was concerned with just the opposite: the extent to which curved lines could act out a complete psychodrama which moved with an intransigent eloquence from initial statement to conflict, and from conflict to resolution. A Riley like *Fall* has nothing to do with the ephemeral distractions of "Op" art.

It is about the ways in which inner stresses can be faced and worked out to our eventual advantage. It takes the formal language which Edvard Munch used in the background of his *The Shriek* (Volume 1), drains away the emotive color, strips the image of its anecdotal element, and ends up with a statement which is as terse as it is compelling.

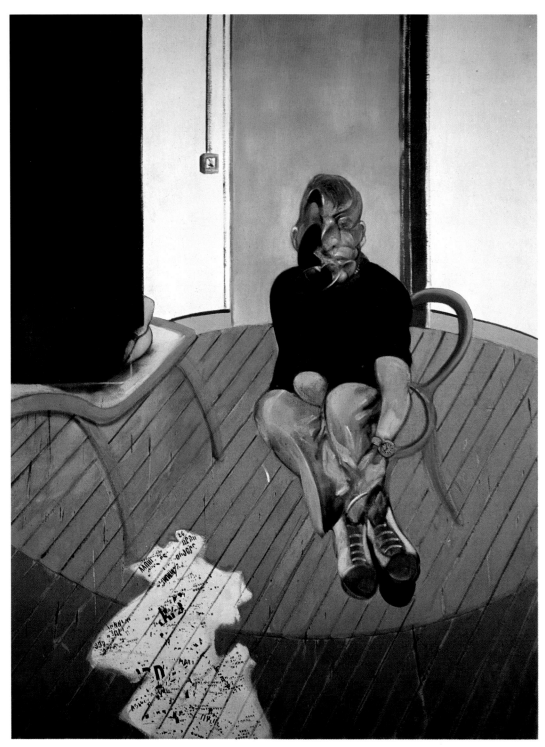

V. Francis Bacon
Self-Portrait, 1973
Collection the artist

Bacon's self-portraits ally a fidelity to literal appearance (in details of dress, bearing and environment) with many a violent departure from our everyday experience. In the interests of a greater immediacy he wrenches, jars, and in general reinvents human appearances, thereby resuscitating that primal surprise which had long been absent from portraiture.

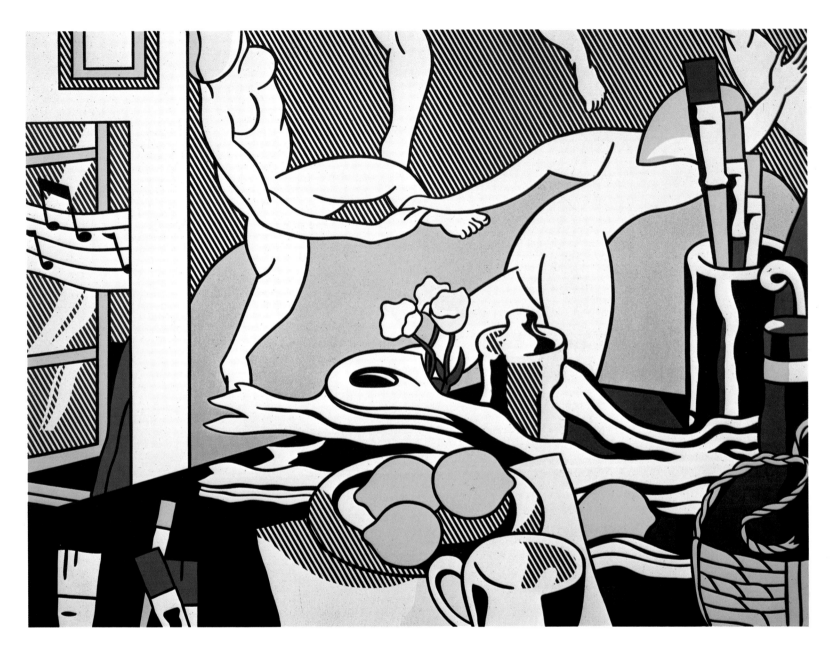

VI. Roy Lichtenstein
Artist Studio—The Dance, 1974
Mr. and Mrs. S. I. Newhouse, Jr., New York

In a famous painting which is now in the U.S.S.R. Henri Matisse took a part of his *Dance* (Volume 2) and made it incidental to another composition. Roy Lichtenstein took up this same idea more than 60 years later. After draining *Dance* of the color which is its most spectacular attribute, he got the image to work with other elements from Matisse, and with memories of his own earlier preoccupations. In this way he was able to carry on a conversation with one of the supreme masters of modern art. His laconic manner of speech does not delude us as to the hardihood of the enterprise as a whole. The mid-1970s have not witnessed a more complex pictorial achievement.

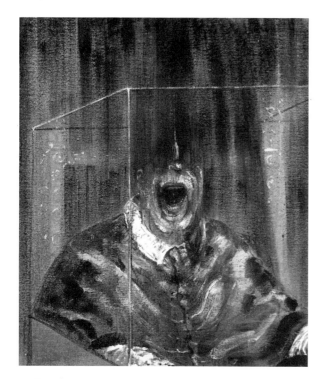

15. Francis Bacon
Head VI, 1949
The Arts Council of Great Britain

Francis Bacon's earlier paintings turned out to have anticipated many a familiar image of the 1960s: Eichmann on trial in his glass box, the newscaster with his eye on the teleprompter, the head of state working overtime to keep history at bay. The open mouth—usually read as a soundless scream—could also stand for a manic hilarity; the costume—Pope? Judge? Masquerader?—added a further ambiguity. Behind all there was the echo of the European Old Master painting—Velázquez, in this case—which Bacon has always aimed to emulate.

art as a whole seemed to have reserves of energy which were in no danger of becoming exhausted. As the 1940s turned into the 1950s, it seemed to Europeans and Americans alike that a great era for art might well be at hand. There was an element of self-satisfaction, as always, in prognoses of this kind. But it is not ignoble to wish for our grandchildren the specific excitement, the sense of invigoration and renewal, with which we first set eyes on the last works of Matisse and the first works of Jasper Johns. Yet we should be rash to count on a continuity of this

kind. We have to remember, disagreeable as it may be, that the great age of Athenian drama lasted only 70 years and that the great age of verse drama in England was even shorter. Between the middle age of Haydn and the death of Brahms, sonata form was one of the loftiest modes of human expression; how often since then has it been used to comparable effect? The great ages of Venetian painting, Dutch painting, Flemish painting went out as if at the turn of a switch. We have very good novelists today, but who could argue that the novel as a form has lately been renewed? In every age there are those who agree with Friedrich von Schiller, greatest of German dramatists, that "beauty too must die, though it holds Gods and men in thrall." Change is the law of life. What we once needed, we need no more. What we once made, we make no more. Why should modern art be exempt from these cruel laws?

"Because we'd miss it," is one answer. "Because it still has a lot to give us," is another. Both could be upheld throughout the 1950s and '60s. The sheer intensity of inter-generational friction during those decades was significant: the future of art was very much a live issue. Painting might be referred to as "bow and arrow art" by those who thought of the future of art in terms of a typewritten message, a ditch in the desert, a suitcase filled with rotting cheese, or free access to an electronic toyshop; but the thralldom of color, in particular, was as strong as ever. There was color as extension, in the stripe paintings of Kenneth Noland; color liberated from drawing, as in the tinted vapors that were as if breathed onto the canvas by Jules Olitski; and color as conspiracy, in paintings by Ad Reinhardt in which time was recruited as an ally and only a long slow look would reveal the true nature of the picture. What people called "the mythic drive behind high art" was still in evidence.

The position of priority taken by painting was, however, much in dispute throughout the 1960s. There were many reasons for this. There was the argument that it was in sculpture that truly revolutionary work was being done. There was the argument that a new world needed not a new art but new kinds of art. There was the argument that the fixed and finite physical nature of painting was bound to rule it out as the locus of some of the deepest of human concerns, at a time when human expectations and motivations were in a state of radical change. There was the argument that both painting and painters were being exploited by economic forces of a detestable sort. There was the argument, finally, that the self-exploratory activities of painting were entering their terminal phase. Ad Reinhardt, for one, believed that he was painting the last pictures which would ever need to be painted. Among established painters there were some who had

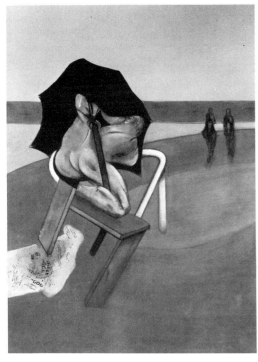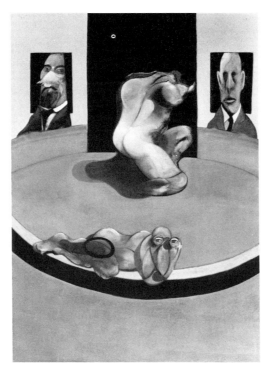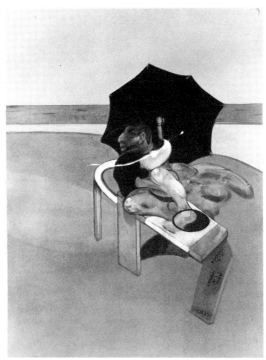

16. Francis Bacon
Triptych May–June, 1974
Collection the artist

Bacon in the 1970s was out to combine the grand formal statements of Old Master painting with a continual awareness of the imagery that is fed into us in our every waking moment: the police photographs, the standard portraits of political leaders (many times lifesize), the discarded fragments of newsprint, the raised circle that sets the scene for high drama in theaters all over the world. He also drew upon the memory of Michelangelo's incomparable evocations of male voluptuousness and upon that element of the irrational that has played so large a part in 20th-century art. From all these he fashioned (as here) compound images that move to and fro, like captive tigers, between the known and the unknown, the clear and the ambiguous, the dreamed and the real.

got themselves into a corner from which there was no getting out; others did the same thing over and over again.

There was something in each and all of these arguments. Painters are people, before and after they are painters. They are as dismayed as the rest of us by what it being done to other people, and to the world, in our name. Painting is an edgy, lonely, uncertain business, and it is very disagreeable to feel that the end product of it is being used to make big money fast for a pack of speculators. It is legitimate in times of crisis for a painter to crave something more direct in the way of communication with other people. In bad times the to-and-fro of human contact is more than ever essential to us, and if that to-and-fro can have something of the urgencies of art, so much the better. Traditional art has a traditional audience and that audience still excludes a large part of the human race. We should not ignore one of the central facts of our time: that new populations and new publics are coming of age all over the world and that such people have the same rights, in matters of art, as the handful of poets, connoisseurs and fellow artists who alone appreciated the best new art before 1914.

WHAT'S NEW FOR ART?

So it is natural to speculate as to whether there may not be a new future for art in the new forms of communication in which our age has specialized. As recently as 1945 we were still deeply conservative in such matters. The formulas of the art world had set fast, like pack-ice, and showed no signs of melting. The rituals of the opera house and the symphony orchestra had not changed

VII. Jasper Johns
According to What, 1964
Edwin Janss, Jr., Thousand Oaks, Calif.

When Jasper Johns painted a major painting in the mid-1960s he gave of his ideas unstintingly. In *According to What* there is the raw material for a dozen lesser careers (and a large-scale preliminary drawing proves that still more was present initially). Johns here turns his attention over and over again to the predicaments into which pure painting had got itself: most notably in the stenciled "RED YELLOW BLUE" (an echo of Mondrian's obsession with primary colors) and in the voluptuous "brushy" passages toward the upper right corner of the canvas. Whole sections of the painting have their own consistent logic, and any other painter would have stayed with that logic and finished up with a coherent whole. But as Johns said in 1965 to the British critic David Sylvester, "At times I will attempt to do something quite uncalled for in the painting, so that the work won't proceed so logically from where it is, but will go somewhere else." "The final suggestion," he went on, "the final statement has to be not a deliberate statement but a helpless statement. It has to be what you can't avoid saying, not what you set out to say." Whence the inexhaustible quality of paintings such as this one.

VIII. Kenneth Noland
Via Blues, 1967
Mr. and Mrs. Robert Rowan, Pasadena, Calif.

Toward the end of the 1960s Kenneth Noland broke with the aggressive
geometry of his earlier paintings and began on a long series of canvases which
derived their fascination from two quite different sources: the notion of
parallel straight lines which streak past the observer as if on their way to
infinity, and the ways in which bands of color of varying width can be made
to react upon one another. The interplay between these two ideas was reward-
ing enough to justify the outlawing of all other considerations.

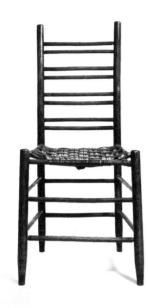

17. Side Chair, Turned,
 c. 1830–45 from
 Nacogdoches, Texas
San Antonio Museum Associ-
 ation Collection, San
 Antonio, Texas

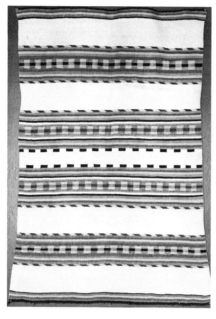

18. Man's Shoulder Blanket,
Navajo Indian, 1875–90
Museum of Fine Arts, Boston

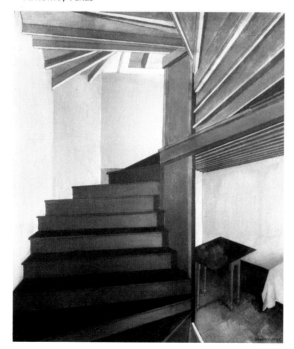

19. Charles Sheeler
Staircase,
 Doylestown, 1925
The Hirshhorn
 Museum and
 Sculpture Garden,
 Smithsonian
 Institution,
 Washington, D.C.

for more than half a century. Going to the theater meant sitting in an auditorium in attitudes unchanged since the time of Sophocles and gazing across the footlights at a play that lasted exactly two and a half hours. A book bound in paper had something wrong with it. A gramophone record was both heavy and fragile and stopped after four minutes. Films were something you saw in a movie house; and movie houses, like the Moscow subway, were vast, ornate, and designed to blind the customer to the drabness of life outside.

All these things were accepted as immutable. Yet it took a bare 25 years for us to adapt to the idea of improvised theater, aleatory music, free-form architecture, magnetic tapes that run for three hours or more, dance dramas that owed nothing to the formalized miming of *Swan Lake.* In all these and many other domains we saw what Mondrian had meant when he said almost 50 years earlier that "we are at the end of everything *old."* Sitting through the 25-minute monologue which constitutes Samuel Beckett's play *Not I,* listening to Karlheinz Stockhausen's electronic *Hymnen,* watching Merce Cunningham and his dance company give a completely new idea of the ways in which life can be spelled out on the stage, we might find it really rather odd that much of painting and sculpture should still be stuck with the materials of Rembrandt and Rodin. Perhaps it is hardly less odd that so many of us should still think of painting and sculpture as separate entities, defined once and forever, when we acknowledge that the future of music may depend on new sources of sound and the future of the theater on modes of expression that are remote from theater as it was understood by the public of Alfred Lunt and Lynn Fontanne.

What we have witnessed, in this context, is the normalization of the avant-garde on the one hand, and the abhorrence of existing conventions on the other. There is nothing new about new sources of sound: the symphony of factory chimneys as it was

At a first glance the sculpture by Donald Judd (fig. 20) might seem to be a work without precedent in art, so completely does it outlaw the traditional elements of sculpture: variety, surprise, "composition," personal handling and evidence of effort. But in point of fact Judd here draws upon the measured regularity and the austere plainness of statement which are fundamental to a certain specifically American aesthetic. That aesthetic turns up all over the place: in the high-backed chair made in the first half of the 19th century (fig. 17), in the Navajo blanket made some 50 years later (fig. 18), and in Charles Sheeler's painting of 1925 (fig. 19), where the stately movement of the staircase is echoed in the ribbing of the ceiling on the right and turns up all over again in the roof. A recurrent America stands, therefore, behind Judd's sculpture, for all its deliberate modernity.

performed in Russia not long after the Revolution is evidence enough of that. There is nothing new about the boredom which many people feel when faced with the stereotyped subscription concert, the ritual "gallery opening" with its herd of free-loading nonentities, or the evening at the theater which costs a fortune and offers very lean pickings in terms of pleasure or enlightenment. Nor is there anything new about the freedom to restructure the arts, or to borrow freely and at will from one discipline in the service of another. To hear Kurt Schwitters recite his wordless poem was one of the great oratorical experiences of the 1920s and '30s. Poetry has arrogated to itself a total liberty on the page ever since Mallarmé published "Un Coup de Dés" in 1895; the Douanier Rousseau fancied himself as a playwright, so did Picasso. Kandinsky wrote a drama to be performed by music, light and moving stage parts alone. But all these activities were incidental to a strenuous creativity in other domains; and they were done in a world which had not yet learned to exploit art for immediate advantage.

That is where the difference lies. There is something radically wrong with a world in which the effective life of most new books is between 14 and 21 days and in which works of art which are part of our universal inheritance are hidden in vaults until the bankers' consortium which owns them can make a sufficient return on its investment. Things of this kind create a climate in which it is inordinately and unnecessarily difficult to produce good new work. They are the enemies of art; and in the 1960s artists began to fight back in the only way that was available to them—by making art that in one way or another was immune to the system.

The new art in question was of many kinds. Much of it was, and is, no good at all. How could it be otherwise? Art cannot function without an agreed social context. There must be some kind of contract, formulated or not, between the artist and the public which he wishes to reach. Contrary to popular belief, no art of consequence was ever produced in isolation. But there are times when both art and its audience are refugees from an environmental madness: this was the case with Dada in its Swiss and German phases, and it was the case with many manifestations of the new in the 1960s. When Claes Oldenburg set up his "Store" at 107 East Second Street, New York City, in the winter of 1961–62 and sold his simulated ray guns, wedding bouquets, wristwatches, pieces of pie, gym shoes, jelly doughnuts, airmail envelopes and inscribed birthday cakes, as a standard store would sell the real thing, he got under the guard of the system. Art was flourishing, but in what looked to be a non-art situation. Oldenburg had solved one of the central problems of the 1960s:

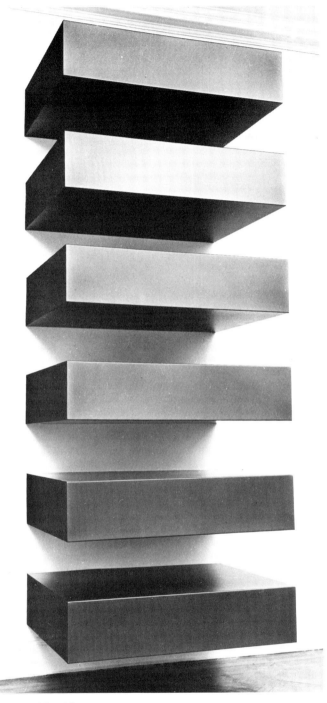

20. Donald Judd
Untitled, 1970
Courtesy Leo Castelli Gallery, New York

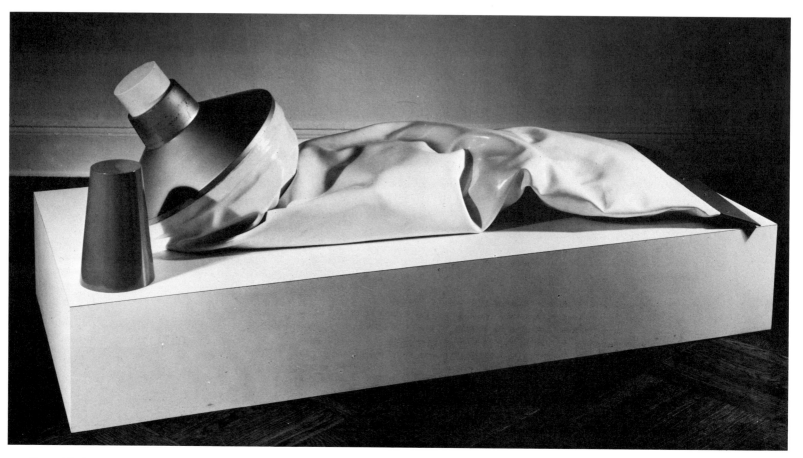

21. Claes Oldenburg
Giant Toothpaste Tube, 1964
Private collection, Fort Worth, Texas

Initially in 1964 the *Giant Toothpaste Tube* came across as an act of defiance. What could such an object have to do with High Art? But in time the almost empty tube of toothpaste took shape in our minds as a traditional reclining figure. And if the detached top of the tube still contradicted this—well, there remained the parallel of the Crusaders' tombs of the 14th century in Europe, where the dead warrior was sometimes portrayed with his helmet at his side.

how to make art without falling prey to the system, and he spelled it out in *Store Days* (1967), which deserves to be one of the classic texts of modern literature: "I know," he wrote, "that down to the last simple detail experience is totally mysterious." And he went on to assert an unexpected kinship: "The only person I know that tried to prove the simplest thing in the world, like a piece of candy, was utterly mysterious was Chirico (in his early days)."

Oldenburg in all this was not taking the dignity out of art. He was giving back to everyday objects the dignity which everyday life had taken away from them. "I am for an art," he said, ". . . that does something other than sit on its ass in a museum. I am for an art that grows up not knowing it is art at all, an art given the chance of having a starting point at zero. I am for an art that is smoked, like a cigarette, smells, like a pair of shoes. I am for an art that flaps like a flag, or helps blow noses, like a handkerchief. I am for an art that is put on and taken off, like pants, which develops holes, like socks, which is eaten, like a piece of pie, or abandoned with great contempt, like a piece of shit."

Nothing could be less like a recipe for an old-style masterpiece. But, as with Dubuffet, high art ended by getting its way; and those resolutely demotic sculptures by Claes Oldenburg have an imaginative vitality which is very rare in mainstream sculpture of their period. That we have to call them "sculptures" is in itself instructive, by the way. If we consider that that same

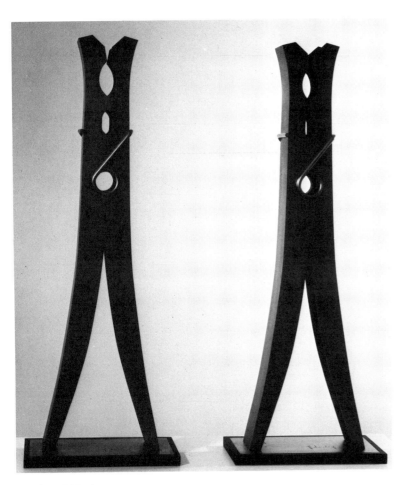

22. Claes Oldenburg
Clothespin-4, 1974
Courtesy Leo Castelli Gallery, New York

Oldenburg has always known that changes of scale bring with them changes of implication. The humble clothespin when magnified and cast in bronze and steel assumes an imperious hominoid look, as if it were halfway through changing into the image of a born leader of man, with his two feet set firmly apart, his left hand tucked into his belt and his big ears cocked to catch the latest news.

word is applied to a Calder mobile, a fluorescent light piece by Dan Flavin, a totem in stainless steel by David Smith and a length of felt hung from a nail by Robert Morris, it will be clear that the word "sculpture" has much wider connotations than the word "painting." The emancipation of sculpture is, in fact, one of the discreeter romances in the cultural life of our century, and it is worthwhile to turn aside for a moment and see how it came about.

THE SPECIFICS OF SCULPTURE

Sculpture has, in a public context, both advantages and drawbacks. It was a drawback to its emancipation that for centuries it had a clearly defined public function. There are millions of people on this earth who have never seen an original painting of any quality; but it is difficult to live in a big city anywhere in the world and not have daily contact with sculptures to which at any rate a certain ambition must be conceded. (Even the badness of those sculptures can liberate the imagination; Giorgio de Chirico took a great deal, for instance, from the public monuments of Turin, in Italy, where the 19th century excelled itself in terms of absurdity.) Sculpture is built into big-city experience in a way that other kinds of art are not, and for that reason it has associations with officialdom which have lately fallen into disrepute.

As against this, sculpture in a private context is very much a minority art. A picture on the wall is part of an almost universal currency of good living. By contrast, a sculpture in the living room most often causes dismay and embarrassment. Backs can be turned to a bad painting; a bad sculpture sits there and defies us to ignore it. Sculpture is apart from the mainstream of living in ways which ensure for it a certain privacy. Its mutations are not monitored as closely as are the mutations of painting. Until recently there was, moreover, a fundamental untractability about the materials of sculpture; this called for a degree of dedication and perseverance which does not arise in the case of the amateur painter. Making sculpture was real work, and the chances of a happy accident of the kind which enriches the life of the Sunday painter were very small. Sculpture has always had, finally, a magical quality—witness the myth of Pygmalion, the sculptor, whose statue of Galatea came to life—and the traditional sculptor stood next to God in his ability to create an unmistakable human being where none had existed before.

This apartness, and this implicitly superior status, have continued into our own time. Sculpture is a crusading art, in ways that are not quite paralleled in painting. The degradation of public sculpture in the second half of the 19th century drove the more thoughtful among younger sculptors to renew and purify the sculptural act. Raymond Duchamp-Villon, the brother of Marcel Duchamp, saw it as fundamental before 1914 that sculpture should be "a reaction against our business era, where money is the master." The great painter-sculptors—Degas, Matisse, Boccioni, Picasso, Giacometti—used sculpture with a freedom and an audacity and a determination to try something quite new which did not always characterize their painting. As for the

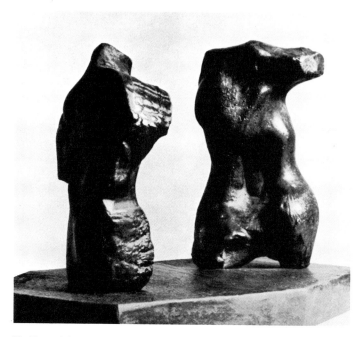

23. Henry Moore
Two Torsos, 1960
Courtesy Wildenstein & Co., Inc., New York

Moore knows what Rodin also knew: that when the human body is fragmented it can tug at our emotions in a way that is quite special. These particular human bodies have been caught at a moment of vigorous and decisive action: a moment at which even the light has found it hard to catch up with them. They have the kind of easy, exultant power which comes of a many-years' mastery.

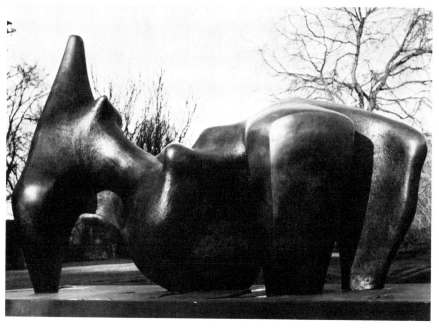

24. Henry Moore
Reclining Figure, 1969–70
Schlesinger Organization, Johannesburg

Moore tussled away for half a century and more at the problem of how to make a reclining female figure which was "larger than life" in a more than literal sense. He meant it to have overtones of epic endurance, overtones of the bare rounded forelands of his native Yorkshire, and overtones of a proud and impulsive sexuality. Sometimes one of these things was uppermost, sometimes another; sometimes, as here, they were perfectly mingled.

sculptor-sculptors—Medardo Rosso, Naum Gabo, Julio Gonzalez, Henry Moore, David Smith, Anthony Caro—they inspired loyalty of a kind which few painters experience. People went to Brancusi's studio in Paris as they would have gone to visit a hermit in the desert. Something fundamental to human dignity was being carried on there: the search for an absolute perfection. In a general way Duchamp-Villon had been quite right when he said in 1913 that "In an era of floating ideas and aspirations, there can be no such thing as a definitive or durable monument"; but this is the sign of a decay in human affairs that must somehow be arrested. Whence the peculiar urgency of modern sculpture at its best; whence, equally, the fascination for sculptors of many kinds, before 1914, of what the art historian Albert E. Elsen has aptly called "the image of the powerful figure whose legs scissor space, whose past and future are measurable only by his tread and not by his name."

If sculpture produced, against all the odds, a definitive and durable monument in the 20th century it was not in the form of a striding figure. Nor did it have the public function which earlier ages had assigned to it. Much of the best sculpture went underground. The full extent of Picasso's activity as a sculptor was not revealed till the 1960s. Matisse's sculpture was always regarded as auxiliary to his painting, though he devoted an immense amount of time to it. Much significant work was lost or destroyed: above all, what was done by Tatlin and others in Russia after 1917. Brancusi's monumental works in Rumania must be the least readily accessible of all the major achievements of modern art. From Medardo Rosso to Joseph Cornell, the making of

three-dimensional objects has doomed those concerned with it to a relative and an unjust obscurity.

Still, there are worse things than obscurity when it comes to the making of great art. (When did Cézanne live in the lime-light?) Original sculpture in the 20th century had the advantage that no publicity-machine was behind it. Brancusi lived off the enthusiasm of "one or two people." Moore in his early 40s could rarely afford the materials for a major work. Henri Laurens lived and died on the edge of penury. David Smith in his studio at Bolton Landing, New York, was never favored (or oppressed, ac-cording to one's point of view) by the adulation which sur-rounded painters without a fraction of his gifts. It would almost be true to say that sculpture in our century has been the secret weapon of art.

This is not, as it might seem, a mere form of words. At any time in the recent history of art there is likely to have been one area which functioned as a touchstone of probity. "Drawing is the integrity of art," said Ingres when faced with the rivalry of Dela-croix; and he meant that drawing was the department of art in which no one can fake. In our own century, painting has carried the banner for modernism; and it is with painting above all that the public associates the idea of the new. But it can be argued that on many an important occasion sculpture darted ahead of painting. There was, on most of these occasions, no follow-through: Picasso turned back to painting after making his *Guitar* in 1912 (Volume 4), Tatlin's reliefs never got the exposure that was vouchsafed to the paintings of his colleagues and contem-poraries, and the rarity and singularity of Brancusi's mature works ensured for them at best an underground reputation. But sculp-ture endures to this day a degree of physical indignity which painting is spared; sculptures in public places attract, in fact, a peculiarly mindless hostility. Sculpture is difficult to show and difficult to talk about. Sculptors incline to be pugnacious—often with good reason—and for all that many bronzes are now cast in quite large editions there is still something about the first-hand experience of sculpture which cannot be counterfeited. Sculpture is immune, therefore, from the vulgarization which lies in wait for painting.

At the same time, a bad sculpture is one of the most blatant forms of environmental pollution. Thomas Mann in his essay on Wagner said that no one can make himself smaller than his true size—the point being that Wagner could not plan a light roman-tic comedy without turning out *Die Meistersinger,* which runs for five hours—and it is equally true that no one can make him-self larger than his true size; a big sculpture which doesn't come off is intolerable. The case for the moral superiority of

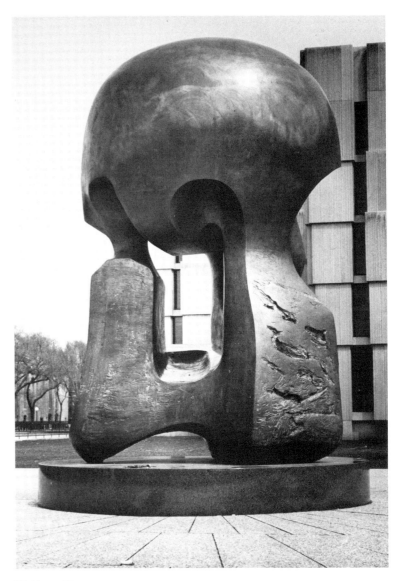

25. Henry Moore
Nuclear Energy, 1965–66
University of Chicago

It may or may not have been a good thing that the atom was ever split at all. But when Moore was asked, in effect, to commemorate that event he came up with something that is characteristically ambiguous and many-layered in its impact. It has elements of the human skull (shaven, as if for an operation on the brain); of the mushroom cloud which follows an atomic explosion; of the armored head, so often treated by Moore before; and of the form that is both fortress and prison. *Nuclear Energy* is here shown at the University of Chicago, where it stands on the site of an old squash court where the first nuclear chain reaction was completed.

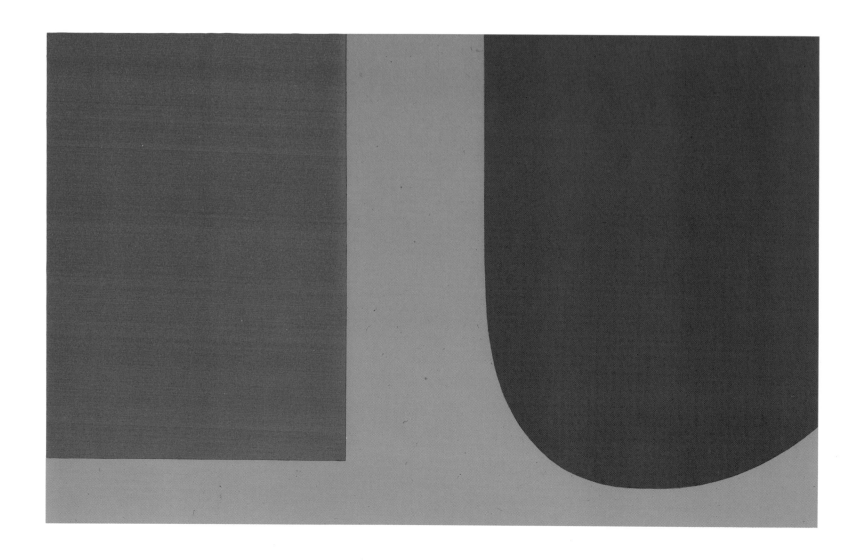

IX. Ellsworth Kelly
Red Blue Green, 1963
Mr. and Mrs. Robert Rowan, Pasadena, Calif.

Kelly lived in Paris from 1948 to 1954. For this and for other reasons, his work has a particularly rich, complex and liberal derivation. There is a grand assurance about his use of color which has not quite been equaled by any other American painter. The shapes in his paintings could not be more abstract, but they are never either arbitrary or doctrinaire. What many people supposed from its title to be yet another evocation of the Brooklyn Bridge was in point of fact derived from a drawing of a sneaker. His many triangular paintings originated from the look of a scarf which he happened to see on the nape of the neck of a young girl in Central Park. The rectangle and the ovoid form in *Red Blue Green* are further examples of Kelly's working method, in that they derived initially from (i) the shape of the window in his studio, (ii) the way in which that shape was distorted when it reappeared as a reflection on the other side of the street. These accidental, "given" motifs were refined and rethought until they were in perfect equilibrium, with the red shape and the blue shape ideally coordinated with the green one.

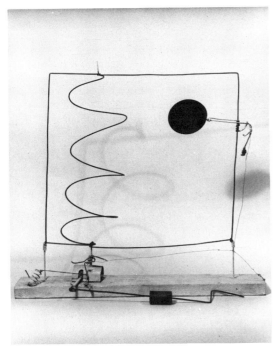

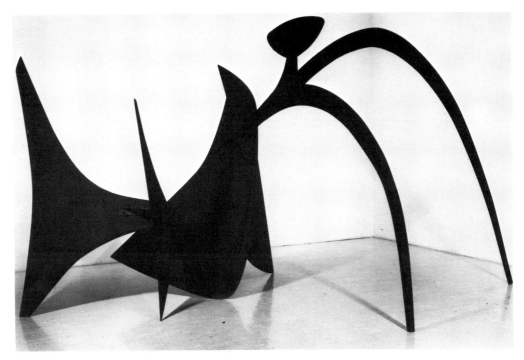

26. Alexander Calder
Crank-Drive Mobile, 1931–32
The Hirshhorn Museum and Sculpture Garden, Smithsonian Institution,
 Washington, D.C.

In Calder's later and better-known mobiles, the wind does the work. But when he began to make mobiles (the name was given to him by Duchamp, by the way) he was still Calder the engineer, and Calder the inventor of the model circus which is now in the Whitney Museum in New York. His mobiles were mechanized, therefore, and their movement was under his control.

27. Alexander Calder
Black Widow, 1959
The Museum of Modern Art,
 New York

Calder's big stabiles combine precision engineering on the one hand with idiosyncratic fancy on the other. *Black Widow* on one level stalks the observer, tempting him to walk into the trap of its two soaring and slender legs. On another it intimidates him with the huge triangular black sheets of metal that constitute an area of force.

sculpture in our century rests on the number and scope of the conventions which had to be overthrown before sculpture could regain its dignity. David Smith put the sculptor's point of view when talking to Thomas B. Hess in 1964. "Sculpture has been a whore for many ages," he said. "It had to be a commissioned thing. Sculpture was not sculpture till it was cast in bronze. Before it was cast, the man who paid for it had certain reservations and designations as to subject matter."

Initially, before 1914, the dignity of sculpture was reclaimed by an isolated piece here and there. Later, where a large body of work existed, it was overshadowed by the priorities accorded to painting. If sculpture impinged on the general consciousness, it was likely to be in the form of artifacts remote from our own culture, such as those from Pre-Columbian Mexico, from Benin or from Easter Island. One of the novelties of the last 50 years,

in this context, is the emergence of modern sculptors with whom a whole generation could identify itself. Instances of this are Alexander Calder, Henry Moore and David Smith, all three of whom in their work got through to the public with a physical immediacy that is very rare.

Something in this is owed to personality. Calder, Moore and Smith come across in their work as men of open, straightforward, downright character, with a contempt for anything mean or evasive: whence comes our confidence in them as human beings. When Calder first made inert materials get up and dance, the world danced with them; and it has been delighted to go on doing so. Some of the formal ideas in his mobiles may have come from Joan Miró, whom Calder has known well for many years; but Calder is the master of a galvanic, free-running humor, and his feeling for life is distinctively that of the most glorious type

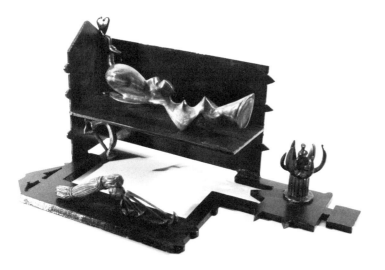

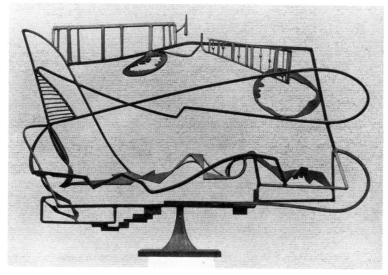

29. David Smith
Hudson River Landscape, 1951
Whitney Museum of American Art, New York

While traveling by railroad between Albany and Poughkeepsie Smith habitually made drawings of the view from the window. He liked especially the spectacular view of the Hudson River; and he took note of the rocky banks, the staircase-like steppes of land that led down to the water, the meandering movement of the river when its level was low toward the end of winter, and the slow circling of the huge clouds above. In this sculpture he synthesized all these things in two-dimensional form with the effect of a man drawing in the air, bending the steel to his will as freely as a landscape draftsman bends the penciled line, and calling upon the memory of natural phenomena to help him to articulate space.

28. David Smith
Reliquary House, 1945
Mr. and Mrs. David Mirvish, Toronto

A reliquary in medieval times was a miniature storehouse in which small objects of particular significance were preserved. Smith had pasted a working drawing for a reliquary of this sort into one of his sketchbooks, and it served as the point of departure for one of the most enigmatic of 20th-century works of art. As elucidated by the art historian Edward Fry in his book on Smith, it was conceived as an opened-out model of a house, in the tradition of Giacometti's *The Palace at 4 A.M.* (Volume 7). In his notes Smith urged himself to "put the hopes upstairs, put the wars below, and hang the past from the ceiling." The "hopes" in question related to the extravagantly voluptuous bronze figure of a naked woman who reclines in the upper part of the house; the "wars" to the conflict between man and woman which is symbolized by the struggle between the bundle of sticks (male) and the schematic image of the moon and its rays (female). (Smith derived the forms of this struggle from a French 17th-century engraving.) The "past" hangs from the ceiling in the form of a private symbol for a locked (and therefore inaccessible) woman. Smith once drew the opened-out sides of the reliquary (which now lie flat on the floor) as respectively male (to the left) and female (to the right). In completing the sculpture he added, on the female side, a small but perfectly proportioned human form which stands for what can emerge eventually, like a flower from unfolded petals, when the locked woman is unlocked and the male-female conflict is resolved.

of American. Quite apart from the contagious amusement of his work, he is in himself one of humanity's more presentable possessions.

At a time in history when it was possible to despair of human nature, Henry Moore likewise said in effect, "There is an alternative": everything in his experience of childhood, everything in his education, everything in his watchful and undeceived understanding of adult life has suggested to him that if human nature is given the right opportunities it may even now redeem itself. This has lately been a very difficult case to argue. A discouraged "No" has been much easier to justify than a constructive "Yes"; and in Moore's affirmative position there was something of that earlier epoch in which D. H. Lawrence in one way and H. G. Wells in another looked forward to a radical change in the prospects for humanity. Lawrence in particular wanted people to know their rights, as human beings, and to act upon them. He wasn't too far, in this, from Henry Moore, and he wasn't too far from David Smith, either.

Smith was a man of universal curiosity—"I want to know everything," he once said, "that has ever been known by any

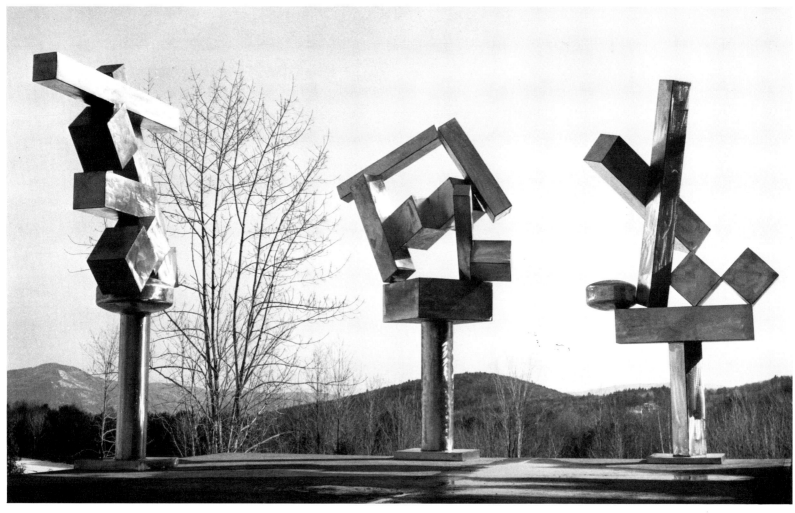

30. David Smith
(left) *Cubi XVIII*, 1964
Museum of Fine Arts, Boston

(center) *Cubi XVII*, 1963
Dallas Museum of Fine Arts

(right) *Cubi XIX*, 1964
The Tate Gallery, London

man"—and he named among his own sources "the illustrations in the Bible of cuneiform, the Sumero-Akkadian style of writing, and other Mesopotamia Valley cultures." "I have always," he went on, "been more Assyrian than Cubist."

David Smith in this was at one with the major artists of this century, who almost without exception have had allegiances which went far beyond what was customary among the major artists of the past. Where formerly the standard progression from the Renaissance through the Middle Ages and back to classical antiquity was thought to fulfill all needs, in our own century the mix is altogether more resourceful. There was something funda-

In the last four years of his life (1961–65) David Smith made a long series of monumental sculptures in stainless steel. He used a restricted number of basic forms: the cube, the rectangular flat slab, the cylinder, the circle, the square turned on its side. Most of the Cubi were conceived in frontal terms, and as a rule they greet us in the attitude of a man attempting to stop a runaway train. They celebrate what the poet W. H. Auden called "the vertical man." Though not organized expressly in human terms, they stand for a certain idea of American manhood: one that is free, open, outgoing, erect and not overly complicated. The glint and sparkle of the stainless steel is fundamental to them. So is their scale, which dominates but does not dwarf us. Smith's was, at the last, an entirely optimistic art; and the Cubi suggest to us that there is nothing that human beings cannot do if they put their minds to it.
(Photographed at Bolton Landing, N.Y.)

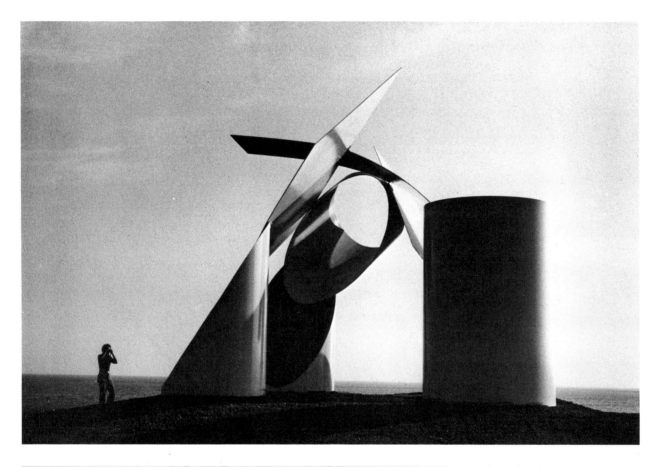

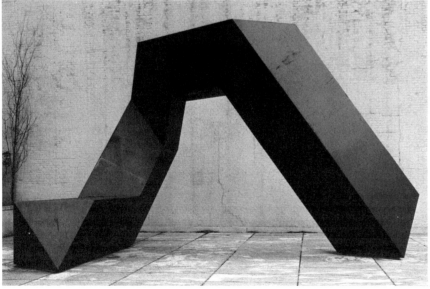

31. Alexander Liberman
Argo, 1974
Monumenta exhibition, Newport, R.I.
Courtesy André Emmerich Gallery, New York
Photograph: André Emmerich

Sculpture and site are not often as neatly matched as here. Alexander Liberman's *Argo*, so deftly suggestive of marine architecture, was photographed at Newport, with one of the world's most famous stretches of salt water close behind it.

32. Tony Smith
Cigarette, 1961–66
The Museum of Modern Art, New York

How to be monumental without being either bombastic or simple-minded is a riddle neatly solved in Tony Smith's *Cigarette*. We feel as if that archetypal sculptural form, the arch, has been wrenched out of shape by a giant's hand. To this impression everything contributes: the awesome scale, the intractable look of the material, and the elegant resolution of the formal problem.

mental, inescapable, about the importance of Islamic art for Matisse, African tribal art for Picasso, Russian folk art for Kandinsky, late 19th-century illustrated magazines for Max Ernst, American Indian sand-painting for Jackson Pollock. But David Smith had the specifically American characteristic that he wanted to bring the business of making art into line with the business of everyday life. Art was not something which called for a specialized posture. Smith wanted, on the contrary, to "draw in proportion to my own size, to draw as freely and as easily, and with the same movements, that I dressed myself with, or that I ate with, or worked with in the factory." What counted was not only the quality of the thing done: it was the quality of the stance before life—or, as Smith put it in 1960—"the freedom of gesture and the courage to act."

David Smith may have been the last major artist to have an absolutely explicit, constructive and optimistic conception of the future of art. In this, as in everything else, he came on as one of Nature's frontiersmen. Art "has existed from the minds of free men for less than a century," he once said. Thus "the freedom of man's mind to celebrate his own feeling by a work of art parallels his social revolt from bondage. I believe that art is yet to be born and that freedom and equality are yet to be born."

Modern art could have no nobler charter than that. Written in 1950, it stands for a large-heartedness, a freedom from corruption, and a breadth of ambition which have largely ceased to characterize the world of art. Smith at that time was as unsuccessful, in worldly terms, as an artist can be. (His income from the sale of his work in 1951 was $333. In 1952 it was nothing at all.) The boom years for art were yet to come, and conditions—for sculpture, at any rate—were roughly as they had been in 1937, when Smith was prompted by the example of the Spanish sculptor Julio Gonzalez to begin making welded sculptures: the work was done to define the sculptor's identity as a free human being, and with no rational prospect of financial success.

Smith was killed in 1965 when his truck overturned on the road. By 1970 a vast machinery of promotion and speculation had fastened on to the making of art, which for most of David Smith's lifetime had been almost as private a matter as theology or pure mathematics. How this came about is a complex question. In part it was an authentic and justified tribute to the new role of art in the imaginative life of the United States. People acknowledged that something extraordinary had happened in art. They might not like it, any more than they liked the music of Elliott Carter or the prose of Gertrude Stein, but they knew that these things redounded to the credit of the United States. To wish to get a piece of the action is intrinsic to human nature. It

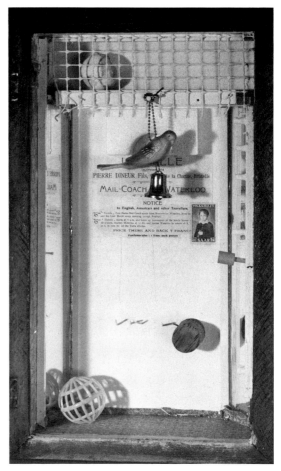

33. Joseph Cornell
Bird and Bell
Estate of Joseph Cornell
Courtesy Albright-Knox Art Gallery, Buffalo, N.Y.

Joseph Cornell invented a form of poetic object—the collaged box—which served him for a lifetime. Himself an all-time champion stay-at-home, he nourished his imagination with notional journeys—in time, in space, and in matters of the heart. In time, he preferred the Romantic period in Europe. In space, he preferred the run-down European hotels in which his favorite 19th-century French poets eked out much of their lives. In matters of the heart his imaginary entanglements were with the great ballerinas—Cerrito, Taglioni, Grisi and Fanny Elsller—of the 1840s. He was also fascinated, as here, by archaic modes of transport. A long-extinct hotel in Belgium, a four-horse coach to a famous battlefield, a bird and a bell—these and other things add up to an image as magical as anything of its kind since Miró's *Object* (1936; Volume 7).

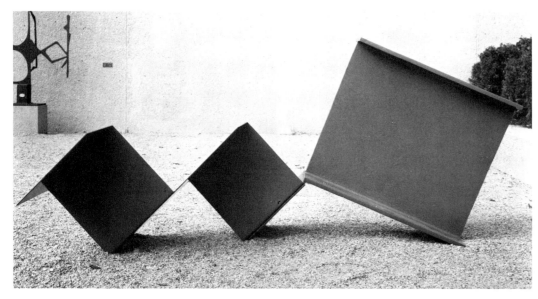

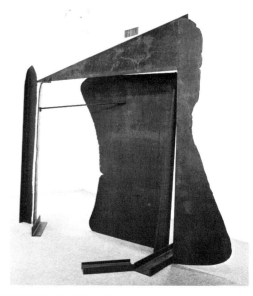

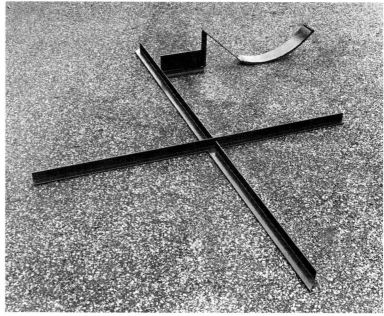

34. Anthony Caro
Rainfall, 1964
The Hirshhorn Museum and Sculpture Garden, Smithsonian Institution,
 Washington, D.C.

Caro's contacts with David Smith in 1963–64 were fruitful for both of them.
Working in the United States at that period, Caro at times used the square or
near-square forms which Smith built up to such effect in his Cubi series (fig. 30).
But where Smith used them to develop ever more imposing emblems of
masculinity, Caro took the weight out of them and made them relate to one
another, as here, with a rare elegance. Where Smith worked by concentration,
Caro worked by dispersion, setting his forms free from any overtone of menace
and devising for them a whole new set of delicate relationships.

35. Anthony Caro
Veduggio Sun, 1973
Dallas Museum of Fine Arts

In 1972–73 Caro paid three visits to Veduggio, Brianza, Italy, where he worked
with a material quite new to him: soft-edged steel. Using scraps from plates
and joists, he held fast to their ruddy, worked-over quality, so that the
sculpture which resulted has none of the immaculateness of *Crosspatch* (fig.
36). The forms have on the contrary a flamboyant, eaten-into and yet spreading
outward look, which is perhaps nearer to the paintings of Helen Frankenthaler
(who had worked in Caro's studio in 1972) than to anything that Caro had
done before. Yet the elements which lie flat on the ground are unmistakably
Caro's, as is the flexible syntax of the piece as a whole. In this, as in the whole
corpus of his work to date, Caro is out and away the most creative sculptor
to have emerged in any country since World War II.

36. Anthony Caro
Crosspatch, 1965
Stephen Mazoh & Co. Inc., New York

Caro has often given his collocations of form the sculptural equivalent of
slender wrists and ankles. Fine-drawn in themselves, they are so lightly
connected with one another as to make us wonder if they have not just floated
together by mutual attraction. In a piece like *Crosspatch,* Caro explores the
poetics of adjacency in ways that make us newly aware of the balance that
should be inherent in our own bodies.

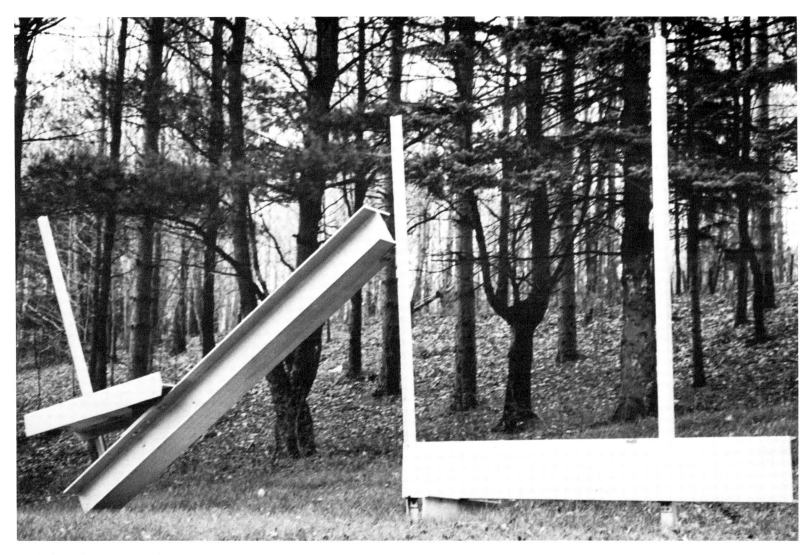

37. Anthony Caro
Atlantic, 1962
Kenneth Noland, South Shaftesbury, Vermont

Caro began as an Expressionist figure sculptor: a precocious manipulator of weighty full-bodied human forms that spread and sprawled in space. But by 1962 he had turned to loose-jointed lateral conjunctions of man-made forms which made no reference to nature. Not only gravity but function was denied— as in *Atlantic,* where the monumental I-beam stands at an angle which it would not conceivably adopt in "real life." The emphasis is on open and transparent sequences of form that get clear away from the monumental, earthbound associations of earlier sculpture. Not forms, but the relations between them, had become the true subject of art.

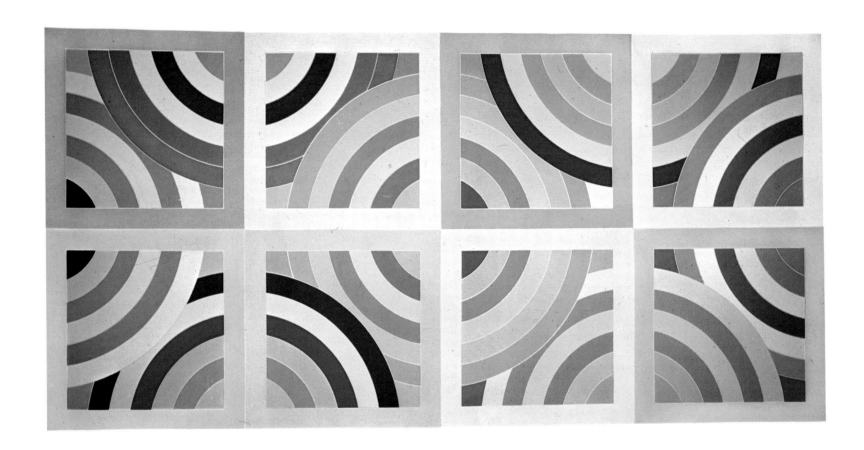

X. Frank Stella
Tahkt-i-Sulayman, Variation II, 1969
The Minneapolis Institute of Arts

In 1967 Frank Stella began work on what was planned as a series of 93 paintings. Twenty-seven separate configurations were involved in all, each one being based on the circular or partly circular movement of a protractor. Most of them bear the names of one or another of the ancient circular cities of Asia Minor. (Stella had visited the Near East in 1963 and has long been preoccupied with Islamic art.) The paintings are very large, with a fine sweetness in the color which in this case is offset by repeated right angles in the general design. The picture both sits and stands with an absolute monumentality; and, as the art historian Robert Rosenblum has said, "the thrusts and counterthrusts, the taut and perfect spanning of great spaces, the razor-sharp interlocking of points of stress all contrive to plunge the observer into a dizzying tour de force of aesthetic engineering."

is fundamental to the thralldom of art that we hope to become what we look at; and if we can look at it every day in our own house the process may perhaps be accelerated. That was the most reputable of the motives which led people to pay high prices for modern art.

Other factors should be spelled out. New money breeds new collectors, and new collectors do not always have the patience, the knowledge, and the discrimination which are basic to the enjoyment of Old Master painting. Much of the best modern art calls for these attributes, but in the art of the 1960s there was much that was altogether readier of access. Ambiguity and complexity played no part in it. There was no question of lingering before it as we linger before Giorgione or Vermeer. Frank Stella was categorical about that in 1964: "One could stand in front of any Abstract Expressionist work for a long time, and walk back and forth, and inspect the depths of the pigment and the inflection and all the painterly brushwork for hours. But I wouldn't ask anyone to do that in front of my paintings. To go further, I would like to prohibit them from doing that in front of my paintings. That's why I make the paintings the way they are." About much of the art of the 1960s there was a bluntness and a blankness which in time gave it the status of an ostentatious and highly speculative form of traveler's check.

Something in this bluntness and blankness came from a revulsion against the art of the 1940s and early '50s. Among the ideas most in disfavor were that of the heroic but foredoomed failure, the approximation that could never become complete, and the acting out, either on the canvas or in three dimensions, of any kind of private drama. There was believed to be something almost obscene about personalized brushstrokes, about sculpture that bore the mark of the shaping hand, and about the traditional European idea of the balanced composition. ("With so-called advanced painting you should drop composition," said Stella.) Much of this was a natural reaction against the extreme subjectivity and the secular mysticism of much that had been made famous since 1950. But it was exploited by a public that did not want to look hard for more than a few moments and by promoters who preferred work that avoided the classic stance—the "now and never again," the "here and nowhere else"—of European art. From this emerged the impersonal series-painting of the 1960s, and the graphics industry which was no more than an expensive variant of autograph hunting, and the multiples which cashed in on the prestige of art but ran none of art's risks. The remarkable thing was not that this situation should have come about, but rather that good work was done from time to time in spite of it.

38. Robert Morris
Brain, 1963–64
Mr. and Mrs. Leo Castelli, New York

Robert Morris rarely goes in for titles. But this cryptic object dates from a period in which he made sculptures in the likeness of the human brain; it is therefore likely that he had in mind an ironical reference when he made this piece, which is in effect a human brain swathed in dollar bills.

AN UNPOSSESSABLE ART

Art went underground, all the same. It had gone underground before, when nobody wanted it: when the audience for the best art numbered six or seven people and the artist—Picasso, at his very best, and Matisse, at his very best—did not even think of putting it on show. Now it went underground for the opposite reason: because everybody wanted it. As insistently as before 1914, the times called for an alternative art. It took many forms; but what these forms had in common was that they questioned the nature of art—and, more especially, of art that was susceptible to instant marketing. Art was to go about its own concerns, in private, and if necessary it was to take forms that denied what was fundamental to marketed art: the possibility of possession.

40. Robert Morris
Untitled, 1969
Bernar Venet, Paris

39. Robert Morris
Untitled, 1974
Courtesy Leo Castelli Gallery, New York

Intermittently over a period of nearly ten years Robert Morris worked on the potentialities of felt as a sculptural medium. Felt in his hands could be made to stand up like steel or aluminum. It could roll on the ground like a gundog exhausted from the chase. It could fulfill any number of rhetorical purposes. It could also cross-refer to current developments elsewhere in art. These three pieces can be taken for instance to refer respectively to the death throes of Abstract Expressionism, to the severe plain statements of Minimal art, and to the downward-swooping runnels of pure paint which Morris Louis used to such magical effect (Volume 11).

41. Robert Morris
Untitled, 1968
Courtesy Leo Castelli Gallery, New York

43. Dorothea Rockburne
Golden Section Painting: Triangle, Rectangle, Square, 1974
Collection the artist

42. Dennis Oppenheim
Attempt to Raise Hell, 1974
Collection the artist

Known earlier for his large-scale cuts into ice and snow, Dennis Oppenheim in 1974 produced an image of quite another kind. A mannequin in corduroys sits facing a bell almost as big as himself. At regular intervals (activated, in point of fact, by an electrical magnet) his head darts forward and he butts the bell. A vast, melancholic, long-echoing sound results; and the image as a whole, with its overtones of pain and compulsion, is as haunting as anything in the stories of Franz Kafka.

In traditional painting the materials form a ground upon which ideas are imposed. In the series of paintings of which this is one Dorothea Rockburne proceeded in the opposite direction. She set out, in other words, to see what ideas could be discovered within preordained material. As her initial format, she took a Golden Section and the square of that section. (The Golden Section has existed since antiquity. It is based on the harmonious division of a line or figure in such a way that the smaller part is to the greater part as the greater part is to the whole.) Each painting is made from a piece of linen which measures 68 x 178 inches. Starting with a Golden Section 110 inches long, and with a determining square which measures 68 inches along each of its sides, Rockburne developed one variation after another. In her earlier work she had used materials—carbon paper, for instance—which had no history in art. But in the Golden Section series she used linen and gesso and clear varnish and glue: materials which reach back to the far past of European painting and end up, in this case, with the formal stiffness of gravecloths. A strange finality results.

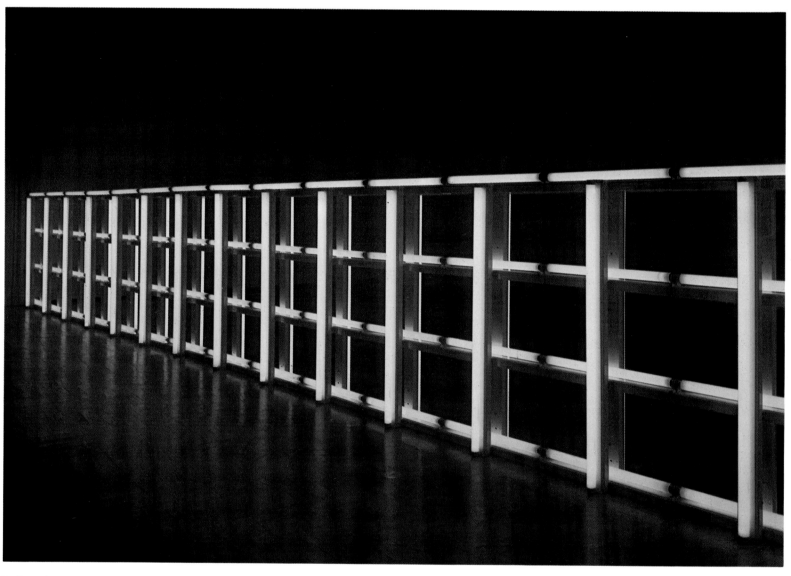

XI. Dan Flavin
Untitled (to Alexandra), 1973
Courtesy the artist and the St. Louis Art Museum

Dan Flavin is self-educated, as an artist, but he has a wide knowledge not only of art history but of such auxiliary studies as relate to his own art: notably the work of William of Ockham, the English 14th-century Franciscan scholar, whose theory of numbers is fundamental to Flavin's work. When Flavin first became aware in 1963 of the possibilities of fluorescent light he did not think of it as an acceptable gadget. It was, rather, "a buoyant and insistent gaseous image which, through brilliance, somewhat betrayed its physical presence into approximate invisibility." It was a medium accessible to everyone, and a medium which had no physical existence. Flavin works with disembodied light; but within that activity he can cross-refer to painting and sculpture. He can also bend space to his will, and bleach or intensify color, and mold shape with the simplest of means, and involve the spectator in ways which neither conventional painting nor conventional sculpture has at its disposal. In *Untitled (to Alexandra)* the strict verticals and the broken horizontals recur with a regularity which recalls the work of his friend Donald Judd. But the mechanics of the work give it an incorporeal quality which is like nothing else in art. The work is both there and not there, fixed and on the move, constant and evanescent, simple and complex.

42

XII. Daniel Buren
Bleecker Street, 1973
Courtesy John Weber Gallery, New York
Photograph: Paul Katz

No one has got out of the gallery system more deftly than Daniel Buren. He takes the whole city for his prey: somewhere within it he secretes one or more striped panels which may or may not attract the notice of the passerby and are unlikely, in any case, to impress themselves upon him as ''art.'' With just one of these panels Buren can change the look of a metropolitan landscape; but he does it, as here, by integration and not by the more ostentatious procedures of earlier times. Where in his combine paintings Robert Rauschenberg literally brought the city into art (Volume 11), Daniel Buren takes art into the city: but surreptitiously.

44. Richard Smith
Ring-a-Lingling, 1966
The Museum of Modern Art, New York

No one, for instance, can buy a work of art that consists in the slightest possible disarrangement of a distant and august landscape. No one can buy a work of art that consists in the temporary and all but invisible readjustment of the city that we live in. If a work of art consists in idea form only, the idea in time will belong to everyone, and the typewritten statement that can be bought and sold is no more than an outdated token. The alternative art of the late 1960s and early '70s took forms that were ephemeral, impalpable, sometimes purely notional. Sometimes it depended on the participation of the viewer: and although this in itself was not new—every work of art has always been completed by the person who looks at it—there was a willed incompleteness about the new art which had not been programmed before.

The instruments of art had never before been so varied. At one extreme there was brought into play every newest refinement of technology: the video-tape, the hologram that hung in the air, the android or humanized robot that clanked and stumbled along the streets of New York, the computer-generated environment, the labyrinth of light and sound that is activated by the public that penetrates it, the crystals in a glass sphere that turn from solid to gas in response to atmospheric conditions. At the other extreme, there were artists who made art with pebbles picked from the foreshore and a worn-down piece of chalk, or with a folded sheet of carbon paper and a few lines ruled in pencil. There were people who went further still and said, with Joseph Kosuth, "I want to remove the experience from the work of art." ("Actual works of art," he also said, "are little more than historical curiosities.") On this last reading, art as it had existed previously was a tautology: an acting-out, in other words, of something that existed already, in definition form, and did not need to be made visible.

These were heady matters, as tempting to the near-genius as to the charlatan, and as accessible to the near-saint as to the ravening opportunist. (I should add that I have illustrated these discussions in ways that are personal to myself and do not pretend to be comprehensive. Some of my favorite artists are not here at all, in fact.) Among the technophiles there were some who simply ran wild, like small boys let loose in a candystore. Among the pseudo-philosophers there were some who could

45. Donald Judd
Untitled, 1966
Courtesy Leo Castelli Gallery, New York

In the middle and late 1960s painting and sculpture more than once ran parallel to one another. The point of this piece by Donald Judd is, for instance, the sequential relationship between the semi-cylindrical protrusions and the flat areas which separate them. The point of the painting by Richard Smith (fig. 44) is the way in which the upper right hand corner of what began life as a flat square form is seen to peel up and out into space, claiming for itself a progressively larger segment of the square. Common to both works is a regard for immaculate finish, a delight in mathematical progression and a classic sense of order.

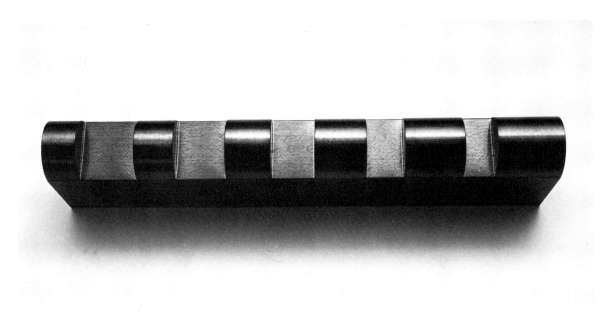

not tell "its" from "it's," let alone master Plato or Kant. Sometimes the wish that art should once again become private was overridden by society. Claes Oldenburg once described how this came about; and his remarks ring true in other and later contexts. "I really don't think you can win. . . . The bourgeois scheme is that they wish to be disturbed from time to time, they like that, but then they envelop you and that little bit is over, and they are ready for the next. . . ." Sometimes, also, elements from marketed art, and from the market situation, made their way in, unbidden. The promotion of personality is as repulsive in this context as the promotion of art. The aesthetics of undifferentiated experience had been put forward to great effect by John Cage, in many of his later compositions, and by Andy Warhol (above all, in his films). It was dismal when the same point of view motivated people who had neither talent nor spontaneous impulse. Where Dada had evolved in an economy of imminent starvation, the art of the early 1970s evolved in an economy dominated by technical superabundance; and something of the billion-dollar silliness of that economy rubbed off on the art.

It was not a healthy situation. On the one hand were artists who financially, and in terms of glamour, had replaced the movie stars of the 1930s as objects of popular attention. On the other were artists who went from town to town like wandering friars. Lodged and fed by small groups of sympathizers, they made and

46. Carl Andre
64 Lead Square, 1969
Annick and Anton Herbert, Ghent, Belgium

Nothing could be less theatrical in intention than this piece by Carl Andre, which consists of 64 flat, identical squares of lead formed up in a collective square without any element of extraneous drama. It is a piece to be walked on, not looked up to. But what initially seemed blank and unyielding turns out in time to be richly characterized, with each square asserting a personality of its own with a specific patina and a specific reaction to light.

XIII. R. B. Kitaj
The Autumn of Central Paris (After Walter Benjamin), 1973
Private collection, Paris

R. B. Kitaj, an American painter long resident in London, works with the recent past of Europe in much the same way as the Old Masters worked with the mythology of Greece and Rome. A voracious and adventurous reader, he constructs from his reading a vision of our times which he then sets down on canvas, mixing old-style "good drawing" with pictorial devices of altogether more recent date. *The Autumn of Central Paris* has for its main subject a Parisian café of the kind that Pierre Bonnard painted in his *Le Café du Petit*

Poucet (Volume 9). At that café is seated among others the German-born critic and essayist Walter Benjamin, who killed himself when the German army entered Paris in 1940. The nonchalance of the party at the table is well offset by the man with the pick, who is taking apart not only the sidewalk on which they are sitting but the society which Benjamin had evoked with such eloquence in his unfinished study of Paris.

XIV. Robert Smithson
Spiral Jetty, Great Salt Lake, Utah, 1970
Photograph: Gianfranco Gorgoni

Robert Smithson was a mixture of poet, filmmaker, landscape gardener, draftsman, geologist and philosopher. He liked to work on a vast scale and in landscapes for which Nature appeared to have no further use. Both in the *Spiral Jetty* and in the *Amarillo Ramp* (fig. 48) his working methods paralleled the use of pouring and dripping in Abstract Expressionism. But where the Action Painters had poured and dripped on a finite canvas, Smithson claimed for himself prerogatives hardly less absolute than those of Jehovah in the Old Testament. He remade the world in an image of his own devising. But he did not forget that all such images have their echoes in the past. The spiral in the *Jetty* is a form that had dominated the imagination of artists and architects from Borromini in the 17th century to Tatlin in the 20th. Smithson also knew that the sun has been figured as a spiral nebula of smaller suns beyond number. And as the critic Joseph Masheck has pointed out Smithson was aware of "the Jungian concept of the *circumambulatio*—a compulsive spiraling-in to one's undiscovered self." What we see in these gigantic works is not a privileged playground, but an attempt to come to terms with American landscape on a scale of which Walt Whitman would have approved.

47

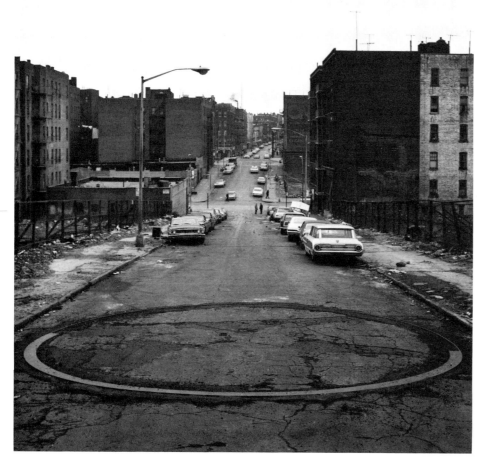

47. Richard Serra
To Encircle Base Plate Hexagram, Right Angles Inverted, 1970
Courtesy Leo Castelli Gallery, New York

Richard Serra is probably best known for huge and minatory sculptures in which one big heavy sheet of metal leans against another. But he has also been interested to insert his art into unexpected places; the form in the foreground was set up in a largely derelict street and in such a way that only the informed passerby would know that art, not function, had been responsible for a change in the landscape.

unmade their art wherever there was an audience, no matter how small. Both were in what is called "art"; yet on the one side a major work cost over a hundred thousand dollars, while on the other there might well be nothing to sell. Each group was pressured, however strangely, by the existence of the other. The established artist was rare in the early 1970s who did not feel that in some way he was the last of his line; many bought time, and bought silence, by stratagems of their own devising.

A paradoxical situation then arose, by which major adventures in art were subject to a form of almost clandestine emigration. The best sculptures of Anthony Caro were shipped out of London, for instance, to American private collections; two German collectors made away with as much of the best American art as they could get their hands on; it was in Holland that Robert Morris and other American artists were encouraged to carry out environmental works for which no bidders were found in the

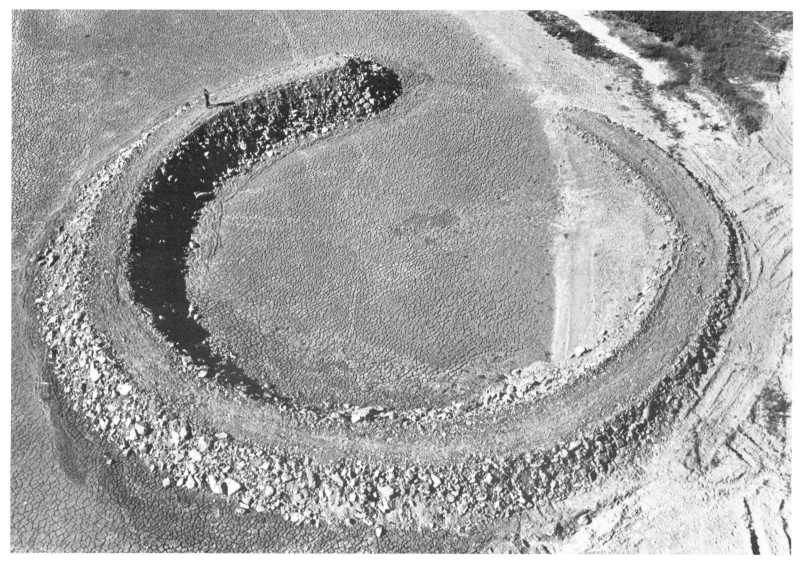

48. Robert Smithson
Amarillo Ramp, Tecovas Lake, Texas, 1973
Photograph: Gianfranco Gorgoni

United States. In this way there was reestablished on a world-wide scale something comparable to the pacific International which had existed in Europe before 1914. The energies inherent in the best modern art were in demand everywhere: in Japan, in Australia, in Israel, and not least in France, where most resolute efforts were made to recapture the ancient prestige of Paris as the city most receptive to the new.

All this gave a look of health and vigor to a situation which in point of fact was short of both these qualities. In America museums were built at enormous expense, only for the trustees to find that they could barely afford to keep them open, let alone find good things to fill them. To many younger artists the museum-system as a whole seemed grossly paternalistic. Museums mirrored, in their view, a power structure and a chain of command which had proved so disastrous in other departments of life that it could not go unchallenged in art. They also stood for

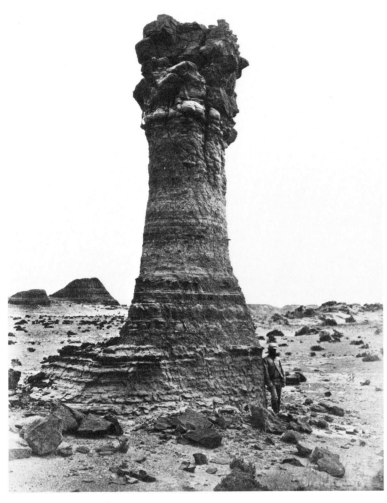

49. Timothy H. O'Sullivan
Washakie Badlands (Wyoming), c. 1870s
Library of Congress, Washington, D.C.

a star-system in which people who could not themselves make art were empowered to set one artist above another. Yet such was the elasticity of the museum-system, and such the self-preservative instinct of society, that even those artists who had taken what amounted to a vow of apostolic poverty were likely to find in time that the museums were ready to take them on their own terms. No form of art was so resolutely anti-spectacular that some ambitious curator would not put it on view. The fear of being left out is as contagious in art as it is in every other area of life; Wilfred Trotter's *Instincts of the Herd in Peace and War* (1923) has yet to go out of date.

From this there results a profound uneasiness: and, with that, a tendency to reverse roles in ways that would have been unthinkable 50 years ago. Collectors once held on to their collections; today they are tempted to trade them in as they trade in their automobiles. Museum directors once planned for eternity when they made a new acquisition; today nothing in their world is stable—least of all their own tenure of office. Artists once kept the past continually in mind, haunting it as Cézanne haunted the Louvre; today they may think, with the sculptor Donald Judd, that "if the earlier work is first-rate it is complete," and that that very completeness makes it no longer relevant. At the ages of 40 Mark Rothko, Barnett Newman, David Smith and Willem de Kooning had still a protective obscurity in which to work; an artist of that age today may well seem to his juniors to be far gone in fogeydom—and the uncomplaining instrument, what is more, of a corrupt and loathsome system.

If we are to feel our way among what will rank as art in the last quarter of our century we have to bear in mind two fundamental aspects of the general situation. One is a degree of technological omnipotence which in the nature of things will grow ever greater. If it is within our power to control and shape the environment in ways never before precedented, and perhaps to guarantee for our physical selves a longevity which formerly belonged to fable alone, then art would not be art if it did not negotiate with these new possibilities. The other factor which we should watch for is something humbler and more conventionally human. It is what is called in German *Torschlusspanik*: the terror of the closing door. The end of art, as art has hitherto been conceived, is more than "the end of an era." It is the end of a god: the death of something which brought reassurance, and brought consolation, and brought an unshakable equanimity. It is very disagreeable, as I said at the outset of this survey, to think that art will one day come to an end. And it is particularly disagreeable when the art of the recent past has been of very high quality.

It is for this reason, as I see it, that the status of art has been

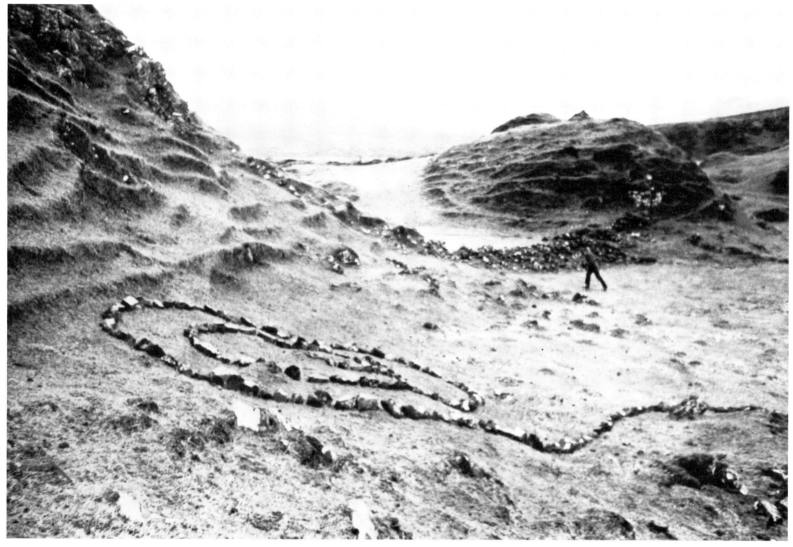

50. Richard Long
Stones on Skye, 1970
Courtesy John Weber Gallery, New York

Among the artists who alter or add to an already existing landscape, none is more inventive than Richard Long. Here in Scotland he made what is in effect a freehand drawing with stones in a natural scene that already has its phantasmagorical aspect. A walker unforewarned might come across it with something of the wonderment that overcame the explorer on the left, who traversed the 40th Parallel just one hundred years ago and came across one of Nature's more bizarre achievements.

claimed for activities which in themselves might seem to be no more than novelty hunting of a particularly fatuous kind. It is for this same reason, and to relieve the strain upon those rare individuals who still produce finite works of art at the highest level, that such efforts have been made to bring the notion of art into a public if not actually into an anonymous domain. If everything is art, and if the life of everyday can be monitored in terms of art, then we shall no longer have to apply to individual exertions the

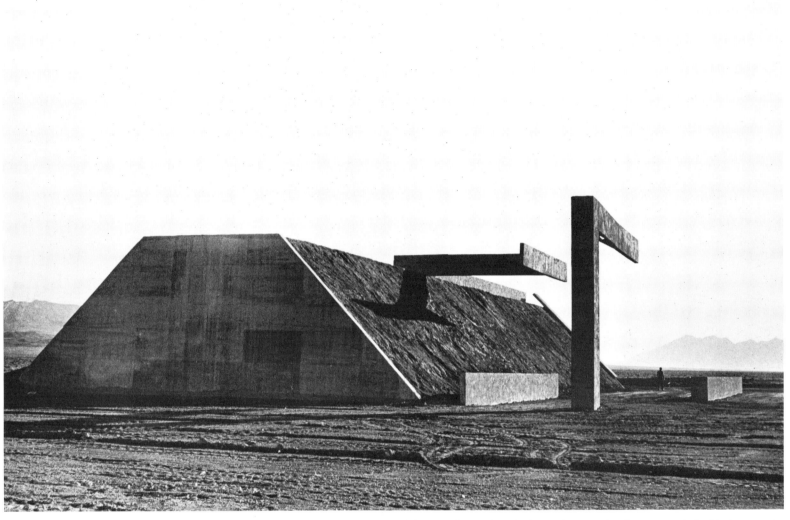

51. Michael Heizer
City, Complex I (side view), Garden Valley, Nevada, 1972–74
Courtesy Fourcade, Droll Inc., New York
Photographs: Gianfranco Gorgoni

The son of an archaeologist, and a man deeply preoccupied with the remote past, Michael Heizer uses modern technology to make grand plain statements on the scale of ancient architecture; and he makes them in distant and lonely places (this one is in a desert valley north of Las Vegas) with an effect of hallucination.

dreaded words "not good enough." We should aim, therefore, to arouse in every human being the kind of superior awareness which is in itself a form of creativity. If this were to become universal—so the argument runs—the gap between art and life would be closed once and for all.

That everyone should be an artist is, on one level, the noblest of dreams: the enfranchisement of one man in a million would give way to the enfranchisement of everyone, without exception.

On a less conscious level it stands, however, for something quite different: the wish to spread among all mankind, and therefore to spread very thin, the responsibility for what is considered in the Bible, and in mythology, as a blasphemous act. It is not for mankind—so the primeval belief ran—to rival the gods. When Marsyas with his reed-pipes challenged Apollo to a trial of skill, Apollo had him flayed alive. When Orpheus made music so beautiful that it overthrew the existing order of things, the gods

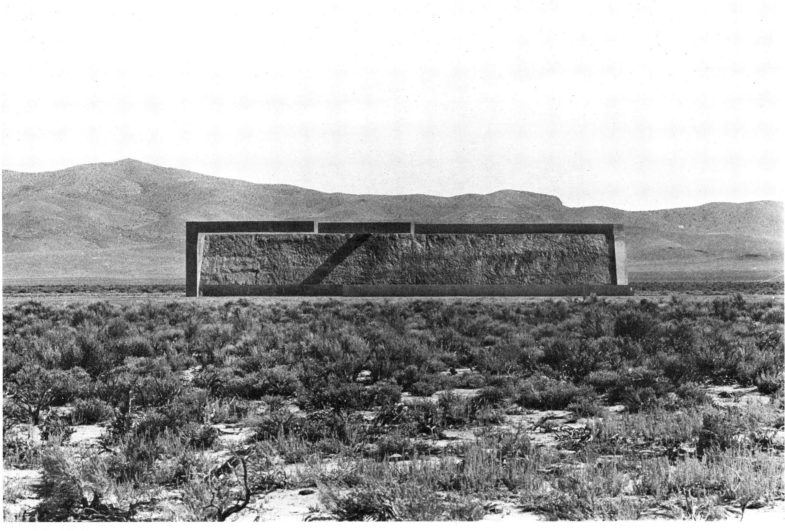

51a. Michael Heizer
City, Complex I (front view), Garden Valley, Nevada, 1972–74

saw to it that he lost his beloved Eurydice and was torn apart by Maenads. When the Hebrews got above themselves and tried to build a tower that would reach to Heaven, Jehovah put an end to it by destroying the unity of language that alone made possible the control of the vast and heterogeneous work force.

Somber warnings, these. Yet in bad times we need to believe that the problems before mankind are not insoluble. We know that the breakdown of art, like the breakdown of literacy, may portend a more general breakdown, and one that is irreversible. If it is forbidden to rival the gods, it is also despicable not to attempt it. The very act of rivalry, with all that it involves in the way of risk and terror and possible retribution, may well be the supreme human act: the one that best justifies our existence and may prevent it from coming to an end. The unfinished and unfinishable near-masterpieces of our time to which I referred earlier result from a belief of this kind.

52. Max Ernst
The Voice of the Holy Father, 1930
Private collection, New York

In 1930, when Max Ernst made this little picture, many of the secrets of our century were still intact. To open the book of the future was a perilous act: one to be watched, as here, with every symptom of dismay. But art could do it, and art has been equal to it, now as then.

For what is the alternative? The silence of the German poet Friedrich Hölderlin. The silence of the French poet Arthur Rimbaud. The silence in old age of the American poet Ezra Pound. The silence of Moses, in Arnold Schoenberg's unfinished opera, when he realized that people were turning away from the truths for which he, Moses, could not find the right words. We may never know why Hölderlin went mad, why Rimbaud left Europe to eke out a living in Africa, or why Pound abjured the gift of tongues that he had used so unwisely. But we know that one of the last poets in classical Latin literature was right when he said that civilization lives by speech and dies by silence. For "speech," in our present context, we should substitute the image in all its forms, finite or variable.

It is difficult, after all, to think of the world as it now is in terms other than those of crisis and emergency. What is at stake is the survival of the earth as a place fit to live on, and of the human race as something that will bear scrutiny. It was not in conditions such as these that the masters of early modern art grew to manhood; and a certain sympathetic indulgence should, I think, be accorded to those who aspire to be their successors. "What can we know for certain?" is a question which has haunted modern art ever since it was first posed by Cézanne. If it has lately been answered primarily in terms of art's own nature—if art, in other words, has aspired primarily to define itself—the lesson in self-knowledge which we can draw from it is nonetheless valid for being metaphorical. Art has provided us with models of our environment ever since cave paintings conjured up the bulls and the bisons that shook the earth as they passed overhead. It is still fulfilling this same function, whether in the panoramic and posthumous masterpiece of Marcel Duchamp which is now in the Philadelphia Museum, or in such more restricted studies as the miniature forest, to be viewed from what felt like a refrigerated trench, which Robert Morris contributed to an exhibition at The Museum of Modern Art in New York. Art is there to make sense of the world, and it should surprise nobody if that is at this moment a very difficult thing to do.

It is possible, too, to be unduly discouraged. The French poet Paul Valéry was very bright indeed as a young man at the turn of this century, and he mixed with people in Paris whose business it was to know what was going on. But, like other very bright people who have been close to the work of their immediate seniors, he took a gloomy view of what was to come. To feel that nothing can be the same again is the most natural of human instincts, and Valéry may well have drawn only assent when he wrote to a friend in 1908 and said, "Will anything great ever again come out of Europe?" I shall have failed in my purpose if I have not convinced the reader that this question called for a full-throated "Yes!" The century, taken as a whole, may well remind us of what was written lately by the British scientist and Nobel prizewinner P. B. Medawar: "To deride the hope of progress is the ultimate fatuity, the last word in poverty of spirit and meanness of mind."

For no one can foresee in what forms of art the next generation will see itself fulfilled and justified. The poet William Carlos Williams spoke ideally well of the effect of great painting when he said that "It is ourselves we seek to see on the canvas, as no one ever saw us, before we lost our courage and our love." This sense of ourselves redeemed and made whole is the greatest gift which one human being can make to another. Art has given it to us, again and again, since the springs of feeling were made over to us, unmuddied, by the Impressionists. What form art will take in the future, no one can say; but no sane society will wish to be without it.

SELECTED READINGS

General

Battcock, Gregory, ed. *Minimal Art: A Critical Anthology.*
New York, E. P. Dutton, 1968.

Benthall, Jonathan. *Science and Technology in Art Today.* (World of Art ser.)
New York, Praeger, 1972.

Brett, Guy. *Kinetic Art: The Language of Movement.*
New York, Reinhold, 1968.

Burnham, Jack. *Great Western Saltworks: Essays on the Meaning of Post-Formalist Art.*
New York, Braziller, 1974.

Celant, Germano. *Arte Povera.*
New York, Praeger, 1969.

Davis, Douglas. *Art and the Future.*
New York, Praeger, 1973.

Hunter, Sam, and Jacobus, John. *American Art of the 20th Century: Painting, Sculpture and Architecture.*
New York, Abrams, 1974.

Klüver, Billy, Martin, Julie, and Rose, Barbara, eds.
Pavilion: Experiments in Art and Technology.
New York, E. P. Dutton, 1972.

Kramer, Hilton. *The Age of the Avant-Garde: An Art Chronicle of 1956–1972.*
New York, Farrar, Straus and Giroux, 1973.

Lippard, Lucy, ed. *Six Years: The Dematerialization of the Art Object.*
New York, Praeger, 1973.

McShine, Kynaston L., ed. *Information.* Exh. cat.
New York, The Museum of Modern Art, 1970.

Meyer, Ursula. *Conceptual Art.*
New York, E. P. Dutton, 1972.

Popper, Frank, *Origins and Development of Kinetic Art.*
Greenwich, Conn., New York Graphic Society, 1968.

Rose, Barbara. *American Art Since 1900.* Revised and enlarged edition.
(World of Art ser.)
New York, Praeger, 1975.

Francis Bacon

Alley, Ronald. *Francis Bacon.* Catalogue raisonné; foreword by John Rothenstein.
New York, Viking, 1964.

Bacon, Francis. *Francis Bacon.* Interviewed by David Sylvester.
New York, Pantheon, 1975.

Russell, John. *Francis Bacon.*
Greenwich, Conn., New York Graphic Society, 1971.

Alexander Calder

Arnason, H. H. *Alexander Calder.*
Princeton, N.J., Van Nostrand, 1966.

Calder, Alexander. *Calder: An Autobiography with Pictures.*
New York, Pantheon, 1966.

Mulas, Ugo. *Calder.*
New York, Viking, 1971.

Anthony Caro

Rubin, William. *Anthony Caro.*
New York, The Museum of Modern Art, 1975.

Whelan, Richard. *Anthony Caro.* Additional texts by Michael Fried, Clement Greenberg, John Russell and Phyllis Tuchman.
Harmondsworth, Middx., Penguin, 1974.

Joseph Cornell

Ashton, Dore. *A Joseph Cornell Album.*
New York, Viking, 1974.

Jean Dubuffet

New York, Guggenheim Museum. *Jean Dubuffet.* Intro. by Thomas M. Messer.
Retrospective exh. cat. New York, The Solomon R. Guggenheim Museum, 1973.

Selz, Peter. *The Work of Jean Dubuffet.*
New York, The Museum of Modern Art, 1962.

Hans Hofmann

Hofmann, Hans. *Search for the Real and Other Essays.*
Cambridge, Mass., MIT Press, 1967.

Hunter, Sam. *Hans Hofmann.*
New York, Abrams, 1963.

Seitz, William C. *Hans Hofmann.* Reprint. First publ. 1963.
New York, Arno for The Museum of Modern Art, 1972.

Ellsworth Kelly

Coplans, John. *Ellsworth Kelly.*
New York, Abrams, 1972.

Goossen, E. C. *Ellsworth Kelly.*
New York, The Museum of Modern Art, 1973.

Bridget Riley

Sausmarez, Maurice de. *Bridget Riley.*
 London, Studio Vista, 1970.

David Smith

Krauss, Rosalind E. *Terminal Iron Works: The Sculptures of David Smith.*
 Cambridge, Mass., MIT Press, 1971.

Smith, David. *David Smith by David Smith.* Cleve Gray, ed.
 New York, Holt, Rinehart and Winston, 1968.

New York, Guggenheim Museum. *David Smith* by Edward F. Fry.
 New York, The Solomon R. Guggenheim Museum, 1969.

Frank Stella

Rosenblum, Robert. *Frank Stella.* (New Art ser.)
 London and New York, Penguin Books, 1970.

Rubin, William S. *Frank Stella.*
 New York, The Museum of Modern Art, 1970.

LIST OF ILLUSTRATIONS

Dimensions: height precedes width; another dimension, depth, is given for sculpture and constructions where relevant. Foreign titles are in English, except in cases where the title does not translate or is better known in its original form. Asterisked titles indicate works reproduced in color.

Andre, Carl
(b. 1935)

64 Lead Square, 1969 (fig. 46)
Lead, 64 x 64 x ⅜ inches
Annick and Anton Herbert, Ghent, Belgium

Bacon, Francis
(b. 1909)

Head VI, 1949 (fig. 15)
Oil on canvas, 37 x 30½ inches
The Arts Council of Great Britain

**Self-Portrait,* 1973 (pl. V)
Oil on canvas, 78 x 58 inches
Collection the artist

Triptych May–June, 1974 (fig. 16)
Oil and pastel on canvas, triptych, each:
 78 x 58 inches
Collection the artist

Buren, Daniel
(b. 1938)

**Bleecker Street,* 1973 (pl. XII)
Courtesy John Weber Gallery, New York
Photograph: Paul Katz

Calder, Alexander
(b. 1898)

Crank-Drive Mobile, 1931–32 (fig. 26)
Wood, wire and sheet metal, 23 x 24½ inches
The Hirshhorn Museum and Sculpture Garden,
 Smithsonian Institution, Washington, D.C.

Black Widow, 1959 (fig. 27)
Painted sheet steel, 7 feet 8 inches x 14 feet
 3 inches x 7 feet 5 inches
The Museum of Modern Art, New York
Mrs. Simon Guggenheim Fund

Caro, Anthony
(b. 1924)

Atlantic, 1962 (fig. 37)
Steel, painted green, 10 feet 7½ inches x 25 feet
 x 1 foot 6 inches
Kenneth Noland, South Shaftesbury, Vermont

Rainfall, 1964 (fig.34)
Steel painted green, 4 feet x 8 feet 3 inches x
 4 feet 3 inches
The Hirshhorn Museum and Sculpture Garden,
 Smithsonian Institution, Washington, D.C.

Crosspatch, 1965 (fig. 36)
Steel painted red, 5 feet 7½ inches x 4 feet
 8½ inches x 7¾ inches
Stephen Mazoh & Co. Inc., New York

Veduggio Sun, 1973 (fig. 35)
Painted steel, 9 feet 3½ inches x 8 feet 2½ inches
 x 5 feet 10½ inches
Dallas Museum of Fine Arts
Gift of the Mr. and Mrs. Edward S. Marcus Fund

Cornell, Joseph
(1903–1973)

Bird and Bell (fig. 33)
Mixed media, 15⅝ x 8½ x 4⅜ inches
Estate of Joseph Cornell
Courtesy Albright-Knox Art Gallery, Buffalo, N.Y.

Dubuffet, Jean
(b. 1901)

The Coffee Grinder, 1945 (fig. 6)
Oil and various materials on canvas, 45½ x 35
 inches
Mr. and Mrs. Ralph F. Colin, New York

Touring Club, 1946 (fig. 7)
Oil on canvas, 38 x 51 inches
Richard S. Zeisler, New York

The Cow with the Subtile Nose, 1954 (fig. 8)
Oil and enamel on canvas, 35 x 45¾ inches
The Museum of Modern Art, New York
Benjamin Scharps and David Scharps Fund

Ernst, Max
(b. 1891)

The Voice of the Holy Father, 1930 (fig. 52)
Paper on paper, collage, 5¾ x 6¾ inches
Private collection, New York

Flavin, Dan
(b. 1933)

Untitled (to Alexandra), 1973 (pl. XI)
Pink fluorescent tubes, 4 feet and 2 feet in length
Courtesy the artist and the St. Louis Art Museum

Frankenthaler, Helen
(b. 1928)

Hommage à H. M. (Henri Matisse), 1971 (fig. 4)
Acrylic on canvas, 80 x 63⅛ inches
Mrs. Ralph Mills, Jr., Chicago

Giacometti, Alberto
(1901–66)

Self-Portrait, 1937 (fig. 12)
Pencil, 19¼ x 12⅜ inches
Private collection, New York

The Nose, 1947 (fig. 11)
Plaster, paint and iron, 32¾ x 16¾ x 16 inches
Kunstmuseum, Basel, Switzerland

Man Pointing, 1947 (fig. 10)
Bronze, 70½ inches high
The Museum of Modern Art, New York
Gift of Mrs. John D. Rockefeller, 3rd

City Square, 1948 (fig. 9)
Bronze, 8½ x 25⅜ x 17¼ inches
The Museum of Modern Art, New York
Purchase

Heizer, Michael
(b. 1944)

City, Complex I, Garden Valley, Nevada, 1972–74
(fig. 51)
Cement, steel and earth, 140 feet x 110 feet x 23
feet 6 inches
Courtesy Fourcade, Droll Inc., New York
Photograph: Gianfranco Gorgoni

Hofmann, Hans
(1880–1966)

Rising Moon, 1965 (pl. II)
Oil on canvas, 84 x 78 inches
Private collection
Courtesy André Emmerich Gallery, New York

Johns, Jasper
(b. 1930)

According to What, 1964 (pl. VII)
Oil on canvas with objects, 7 feet 4 inches x
16 feet
Edwin Janss, Jr., Thousand Oaks, Calif.

Judd, Donald
(b. 1928)

Untitled, 1966 (fig. 45)
Painted galvanized iron, 5 x 40 x 8½ inches
Courtesy Leo Castelli Gallery, New York

Untitled, 1970 (fig. 20)
Anodized aluminum, 8 boxes (6 shown), each:
9 x 40 x 31 inches
Courtesy Leo Castelli Gallery, New York

Kelly, Ellsworth
(b. 1923)

Red Blue Green, 1963 (pl. IX)
Oil on canvas, 7 feet x 11 feet 4 inches
Mr. and Mrs. Robert Rowan, Pasadena, Calif.

Kitaj, R. B.
(b. 1932)

*The Autumn of Central Paris
(After Walter Benjamin),* 1973 (pl. XIII)
Oil on canvas, 60 x 60 inches
Private collection, Paris

Liberman, Alexander
(b. 1912)

Argo, 1974 (fig. 31)
Painted steel, 15 feet x 31 feet x 36 feet
Photographed by André Emmerich at the
Monumenta exhibition, Newport, R.I.
Courtesy André Emmerich Gallery, New York

Lichtenstein, Roy
(b. 1923)

Artist Studio—The Dance, 1974 (pl. VI)
Oil and magna on canvas, 8 feet x 10 feet 8 inches
Mr. and Mrs. S. I. Newhouse, Jr., New York

Long, Richard
(b. 1945)

Stones on Skye, 1970 (fig. 50)
Courtesy John Weber Gallery, New York

Man's Shoulder Blanket, 1875–90 (fig. 18)
Navajo Indian
Tapestry weaving, wool yarns, 52 x 80 inches
Museum of Fine Arts, Boston
Gift of John Ware Willard

Matisse, Henri
(1869–1954)

Dahlias and Pomegranates, 1947 (fig. 1)
Brush and ink, 30⅛ x 22¼ inches
The Museum of Modern Art, New York
Abby Aldrich Rockefeller Fund

"The Sword Swallower," plate 13 from *Jazz,* 1947
(fig. 3)
Pochoir, 15½ x 11 inches
Published by Tériade for Editions Verve,
Paris, 1947

Nude with a Necklace, 1950 (fig. 2)
Brush and ink, 20⅞ x 16⅛ inches
The Museum of Modern Art, New York
The Joan and Lester Avnet Collection

Memory of Oceania, 1953 (pl. I)
Gouache and crayon on cut and pasted paper over
canvas, 9 feet 4 inches x 9 feet 4⅞ inches
The Museum of Modern Art, New York
Mrs. Simon Guggenheim Fund

Mondrian, Piet
(1872–1944)

Composition, 1938–44 (fig. 13)
Charcoal on canvas, 27½ x 28½ inches
Courtesy Sidney Janis Gallery, New York

Victory Boogie-Woogie, 1943–44 (pl. IV)
Oil on canvas, 70¼ x 70¼ inches
(on the diagonal)
Mr. and Mrs. Burton Tremaine, Meriden, Conn.

Moore, Henry
(b. 1898)

Two Torsos, 1960 (fig. 23)
Bronze (cast 1962), 8 x 9 inches
Courtesy Wildenstein & Co., Inc., New York

Reclining Figure, 1969–70 (fig. 24)
Bronze, 13 feet long
Schlesinger Organization, Johannesburg

Nuclear Energy, 1965–66 (fig. 25)
Bronze, 12 feet high
University of Chicago
Photograph: David Finn

Morris, Robert
(b. 1931)

Brain, 1963–64 (fig. 38)
Mixed media, 7½ x 6½ x 5¾ inches
Mr. and Mrs. Leo Castelli, New York

Untitled, 1968 (fig. 41)
Felt, ⅜ inch thick
Courtesy Leo Castelli Gallery, New York

Untitled, 1969 (fig. 40)
Felt, ¾ inch thick, installed 6 feet x 15 feet
Bernar Venet, Paris

Untitled, 1974 (fig. 39)
Felt and metal, 99 x 76¾ x 36¼ inches
Courtesy Leo Castelli Gallery, New York

Noland, Kenneth
(b. 1924)

Via Blues, 1967 (pl. VIII)
Acrylic on canvas, 7 feet 6⅛ inches x 22 feet
Mr. and Mrs. Robert Rowan, Pasadena, Calif.

Oldenburg, Claes
(b. 1929)

Giant Toothpaste Tube, 1964 (fig. 21)
Vinyl over canvas filled with kapok,
 25½ x 66 x 17 inches
Private collection, Fort Worth, Texas

Clothespin-4, 1974 (fig. 22)
Bronze and steel (edition of 9), 48¾ inches high,
 including base
Courtesy Leo Castelli Gallery, New York

Oppenheim, Dennis
(b. 1938)

Attempt to Raise Hell, 1974 (fig. 42)
Cloth figure, cast aluminum head, electrical
 magnet and metal bell
Collection the artist
Courtesy John Gibson Gallery, New York

O'Sullivan, Timothy H.
(1840–82)

Washakie Badlands (Wyoming), c. 1870s (fig. 49)
Photograph
Library of Congress, Washington, D.C.
Prints and Photographs Division

Picasso, Pablo
(1881–1973)

Les Femmes d'Alger, February 14, 1955 (fig. 5)
Oil on canvas, 45½ x 58¼ inches
Mr. and Mrs. Victor W. Ganz, New York

Pollock, Jackson
(1912–56)

Blue Poles (Number 11, 1952), 1953 (pl. III)
Enamel and aluminum paint with glass on canvas,
 6 feet 11 inches x 16 feet
Australian National Gallery, Canberra

Riley, Bridget
(b. 1931)

Fall, 1963 (fig. 14)
Acrylic on board, 55½ x 55¼ inches
The Tate Gallery, London

Rockburne, Dorothea
Golden Section Painting: Triangle, Rectangle,
 Square, 1974 (fig. 43)
Clear varnish, gesso, chalk line, linen and glue,
 54⅞ x 84 inches
Collection the artist

Serra, Richard
(b. 1939)

To Encircle Base Plate Hexagram, Right Angles
 Inverted, 1970 (fig. 47)
Steel, 26 feet diameter
Courtesy Leo Castelli Gallery, New York

Sheeler, Charles
(1883–1965)

Staircase, Doylestown, 1925 (fig. 19)
Oil on canvas, 24 x 20 inches
The Hirshhorn Museum and Sculpture Garden,
 Smithsonian Institution, Washington, D.C.

Side Chair, Turned, c. 1830–45
 From Nacogdoches, Texas (fig. 17)
Ash and elm with hickory bark seat
San Antonio Museum Association Collection,
 San Antonio, Texas

Smith, David
(1906–65)

Hudson River Landscape, 1951 (fig. 29)
Steel, 75 inches long
Whitney Museum of American Art, New York

Reliquary House, 1945 (fig. 28)
Bronze and steel, 23½ x 12¼ x 11¾ inches
Mr. and Mrs. David Mirvish, Toronto

Cubi XVII, 1963 (fig. 30)
Stainless steel, 9 feet high
Dallas Museum of Fine Arts
The Eugene and Margaret McDermott Fund

Cubi XVIII, 1964
Stainless steel, 9 feet 8 inches high
Museum of Fine Arts, Boston
Gift of Stephen D. Paine

Cubi XIX, 1964
Stainless steel, 9 feet 5 inches high
The Tate Gallery, London

Smith, Richard
(b. 1931)

Ring-a-Lingling, 1966 (fig. 44)
Synthetic polymer paint on shaped canvas with
 sheet aluminum, in 3 parts, overall:
 7 feet x 20 feet 11¾ inches x 17 inches
The Museum of Modern Art, New York
Purchase

Smith, Tony
(b. 1912)

Cigarette, 1961–66 (fig. 32)
Painted steel, 15 feet 1 inch x 25 feet 6 inches x
 18 feet 7 inches
The Museum of Modern Art, New York
Mrs. Simon Guggenheim Fund

Smithson, Robert
(1938–73)

Spiral Jetty, Great Salt Lake, Utah, 1970 (pl. XIV)
Photograph: Gianfranco Gorgoni

Amarillo Ramp, Tecovas Lake, Texas, 1973 (fig. 48)
Photograph: Gianfranco Gorgoni

Stella, Frank
(b. 1936)

Tahkt-i-Sulayman, Variation II, 1969 (pl. X)
Acrylic on canvas, 10 feet x 20 feet
The Minneapolis Institute of Arts
Gift of Mr. and Mrs. Bruce B. Dayton

PHOTOGRAPH CREDITS

Rudolph Burckhardt, New York, 20, 45; Richard
Cheek, Cambridge, Mass., 17; Geoffrey Clements,
Staten Island, N.Y., 5, 29, 38, 44; André Emmerich,
New York, 31; David Finn, New York, 25;
Gianfranco Gorgoni, New York, XIV, 48, 51;
Bruce C. Jones, Huntington, N.Y., 39; The Jones-
Gessling Studio, Huntington, N.Y., 21; Paul Katz,
New York, XII; Kate Keller, New York, 32; James
Mathews, New York, 2, 9; Eric Pollitzer, Garden
City Park, N.Y., 4, 8, 13, 22, 27, VI, IX; Nathan
Rabin, New York, 43; Sunami, 1, 3, 6, 7, 10;
Malcolm Varon, New York, I, II; John Webb,
London, 15.

58

INDEX
TO THE SERIES

An index to artists' names, picture titles and the major art movements. Volume numbers are in bold type. Page numbers are in roman type. Picture titles are in italics.